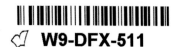
LEGENDARY LOCALS

OF

THE SOUTHERN BERKSHIRES

MASSACHUSETTS

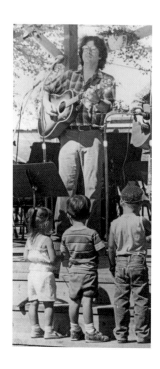

Sports Stars
Sports heroes abound in the Southern Berkshires. Several are featured elsewhere in this book. Pictured here is the 1956 Searles High School basketball team. A very partial list of other sports notables includes youth sports advocates Terry Koldys and the Passetto family; golfers Andrew Congdon, James Peace, Clem Rafferty, and Davis Mullany; basketball and soccer officials/coaches/players Michael and Thomas Kinne; girls' basketball coaches David Kinne and John Lucey; basketball players Elbridge Evans, Henry Van Lennep, Jack Dunn, John B. Hull Jr., William Caligari, Murray Tracy, Wray Gunn, William Owens, Anna Whalen, James McGarry, Sterling Bennett, and James Golden; boxers Edward Decker, Edward Ely, and David Shade; baseball players Edward Farr, Thomas Siok, John Raifstanger, David Emprimo, Peter Noonan, William Cosgriff, and Francis Sigoski; football player Marshall Newell; track-and-field stars Dolf Berle, Ronna Deffer, Susan Plungis, Arthur Gennari, Jeffrey Howard, and Olympic coach Charles French; soccer player Francisco Girona; weightlifter William Kennedy; cyclists John Decker, George Knight, and Arthur Barnes; umpire Eugene Sullivan; wrestlers David Lupiani and Eric Hagberg; multisport stars Susan Carpenter, Kristen Kinne, and John Beacco; and swimmer Margaret Rosenbaum. (Photograph courtesy of Great Barrington Historical Society.)

Page 1: **David Grover**
Musician David Grover performs for three adoring fans in 1987. (Photograph by Donald Victor.)

LEGENDARY LOCALS
─── OF ───

THE SOUTHERN
BERKSHIRES
MASSACHUSETTS

GARY LEVEILLE

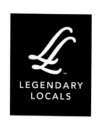

LEGENDARY
LOCALS

Legendary Locals is an imprint of Arcadia Publishing
Charleston, South Carolina

Printed in the United States of America

Library of Congress Control Number: 2013946005

For all general information, please contact Arcadia Publishing:
Telephone 843-853-2070
Fax 843-853-0044
E-mail sales@arcadiapublishing.com
For customer service and orders:
Toll-Free 1-888-313-2665

Visit us on the Internet at www.arcadiapublishing.com

Dedication
To all of the extraordinary people of the Southern Berkshires—past and present—who make this cultural and scenic oasis such an interesting, inspiring, and entertaining place to live. And to all of the wonderful photographers—now and then—who made this project a fascinating treasure hunt.

On the Front Cover: Clockwise from top left:
Yvonne Twining Humber (Courtesy of Martin-Zambito Fine Art; see page 97), Roger the Jester (Photograph by David Moulthrop; see page 87), William Walsh (Photograph by Donald Victor; see page 36), William Stanley (Courtesy of Bernard Drew collection; see page 26), William Cullen Bryant (Courtesy of Great Barrington Historical Society; see page 15), Catharine Sedgwick (Courtesy of BerkshireArchive.com; see page 18), Rachel Fletcher (Photograph by Steve Moore; see page 96), Elizabeth "Mumbet" Freeman (Courtesy of Massachusetts Historical Society; see page 13).

On the Back Cover: From left to right:
Marie Tassone (Courtesy of Great Barrington Historical Society; see page 44), Tom "Jay" Jaworski (Photograph by Marie Tassone; see page 45).

CONTENTS

ACKNOWLEDGMENTS

Many thanks to Erin Vosgien and Kris McDonagh of Arcadia Publishing, who have been patient, helpful, and cheerful managing editors from concept to completion.

I am most grateful to Dr. Brian Burke, who went beyond the call to help with research about 18th-century personalities; and to James Parrish, for his knowledge and near-photographic memory. Also, thanks to Donald Victor, who cheerfully tolerated my nagging and provided a plethora of wonderful photographs.

Much gratitude goes to my colleagues on the Great Barrington Historical Commission and in the Great Barrington Historical Society: Doreen Atwood, Daniel Bailly, Marilyn Bisiewicz, Bernard Drew, Michael Fitzpatrick, Sharon Genin, Donald Howe, Malcolm Fick, Paul Ivory, Laura Katz, William Nappo, Dr. Ronald Majdalani, James Mercer, Debbie Oppermann, Mark Pruhenski, Patricia Ryan, Barbara Syer, Robert Tepper, and David Rutstein.

Many other historians, colleagues, family, and friends have offered assistance, encouragement, and suggestions for this project. A partial list includes Barbara Allen, Ronald Bernard, Brian Dawe, Kristen Kinne Flynn, Sean Flynn, Derek Gentile, Leonard Hall, Joyce Hawkins, Nancy-Fay Hecker, David Kinne, Patricia Kinne, Audrey Leveille, Lion Miles, James Miller, Paul O'Brien, Cora Portnoff, Judy Rupinski, Robert Salerno, Donald Latino, Richard Wilcox, and Henry Wingate. Thank you.

INTRODUCTION

The Southern Berkshires are blessed with a superb selection of remarkable residents, past and present. This book celebrates many who have made a memorable impact on the community throughout its history. With such a plethora of personalities from the past, the selections were incredibly challenging.

My original plan was to feature local legends and pioneering personalities exclusively from the past. But after discussion with the publisher, we decided that the book would benefit from a sampling of noteworthy folks who are still alive and kicking. With only 128 pages and hundreds of suitable subjects to draw upon, no matter whom I chose, I will inevitably hear, "How could you have left out so-and-so?" And, conversely, "Why the hell did you include such-and-such?"

I was also encouraged to include "unsung heroes," figures quite different from legends. With all the fine teachers, public servants, police officers, firefighters, EMTs, doctors, merchants, restaurateurs, carpenters, artists, entrepreneurs, and philanthropists in the area, I could fill three volumes. What to do? Well, the reader is asked to think of each person in this book as a symbol or representative of all the wonderful inhabitants of the Southern Berkshires. This book can only include a fraction of the folks who deserve to be highlighted. Down the road, a second volume could be filled with equally deserving citizens.

The next challenge was to set the geographic parameters of the "Southern Berkshires." These days, school districts are often used as boundary markers, as citizens are linked socially, and financially, by these districts. So, the geographic scope of this book are the towns in Berkshire Hills Regional School District, Southern Berkshire Regional School District, and Farmington River Regional School District. Although Great Barrington, Stockbridge, and Sheffield are featured, also included are fantastic folks from Alford, Egremont, Monterey, Mount Washington, New Marlborough, Otis, Sandisfield, Tyringham, and West Stockbridge.

There is one anomaly that requires the reader's kind understanding. Local legends associated with the Tanglewood "neighborhood" could fill an entire book. Although a good chunk of Tanglewood is technically within Stockbridge, it is most associated with Lenox. So, those "stars" should be saved for a future book about Lenox, Lee, and Central Berkshire.

Readers are likely well aware that Southern Berkshire County is a magical place. Some call it paradise. The special synergy that exists here between people and place has inspired remarkable residents for centuries. The list of notables is a long one, stretching from Stockbridge missionary John Sergeant to Mohican Native American Aaron Umpachene. It includes African American Mumbet (Elizabeth Freeman) and novelist Catharine Sedgwick. From editor and poet William Cullen Bryant to education pioneer Elizabeth Blodgett Hall, the Housatonic Valley and surrounding hills have proved to be a haven for inventors and industrialists, artists and activists, entrepreneurs and educators. Stockbridge summer resident and legendary sculptor Daniel Chester French once said to a New York reporter, "I spend six months of the year up there, that is heaven." W.E.B. Du Bois, Norman Rockwell, Cyrus Field, William Stanley, Laura Ingersoll Secord, and other luminaries have passed on to a different heavenly plane. Still, the region continues to produce local legends and unsung heroes, including community activist Rachel Fletcher, cosmetics entrepreneur Jane Iredale, astronaut Story Musgrave, and author Simon Winchester. So, let us meet and greet some interesting folks—past and present.

It was the end of the Ice Age in North America. The massive glacier that scoured the landscape made its final soggy retreat to the north. Abundant plant and animal life returned to the Southern Berkshires rather quickly, geologically speaking. Mastodons and woolly mammoths roamed the turf, and human visitors known as Paleo-Indians followed their prey here. Little is known about these prehistoric Berkshirites, but they lived here at least seasonally. Radiocarbon dating of artifacts found near Kampoosa Bog in Stockbridge indicates a Native American presence at least 4,000 years ago.

For unknown reasons, the ancient aboriginal encampments were abandoned. Later, the Housatonic Valley and surrounding hills became part-time hunting grounds for Mohican Indians who drifted over from

their Hudson River settlements. At some point after Henry Hudson first sailed up the Hudson River in 1609, the Mohicans established small, semi-nomadic, but permanent settlements in South Berkshire.

John Konkapot, Aaron Umpachene, and Jehoiakim Shawenon

By the 1720s or earlier, Dutch and English traders, squatters, and settlers wandered into the Southern Berkshires along narrow Indian trails. They found local Native Americans living primarily in a few small villages along the Housatonic River. According to tradition, one of the sites in Great Barrington was referred to as the "Great Wigwam." Some believe the site was near the present-day Congregational Church in Great Barrington. Others argue quite convincingly that the Great Wigwam was the settlement later called Skatekook, situated near the present-day Great Barrington/Sheffield town line on a hill in the vicinity of West Sheffield Road. This is where Sachem Aaron Umpachene (c. 1676–1751) lived. Another settlement, located near present-day Stockbridge, was the home of Chief John Konkapot (c. 1691–c. 1765), also known by his Mohican name, Pophnehonnuhwoh.

During early settlement, a portion of what is now the Southern Berkshires was often referred to as "Housatonnuck." Some say this was a Native American word for "over the mountain." The future township lands were purchased in 1724 from Chief Konkapot and 20 other Mohican Indians for 460 pounds, 3 barrels of cider, and 30 quarts of rum. The town of Sheffield, officially incorporated in 1733, was the first town in what is now Berkshire County. Its North Parish was set off and incorporated as Great Barrington in 1761.

John Konkapot was a well-respected chief dedicated to the advancement of his nation. He was also a friend to the English settlers and a man of peace. Konkapot, a member of the Turkey Clan, usually signed documents with a pictorial symbol of a turkey foot.

Aaron Umpachene, also a sachem, probably played a subordinate role to Konkapot. Both were reluctant, at first, to accept Christianity, but the two men looked at the apparent success of the English moving into their territory, then reflected on their own tribes' severe setbacks. Perhaps they decided that they had nothing to lose in adopting the religion. It appears, however, that Umpachene was less enthusiastic about the changes coming to the tribe. He objected to some of the measures being adopted, and, from time to time, lapsed into a battle with alcoholism. Both men served as selectmen in Stockbridge for several terms, trying to protect their land from conniving settlers who sought to take it as their own. They consistently petitioned Boston for justice in matters of fairness in town affairs and land ownership. Today, the Mohicans are located in Wisconsin, where the memories of Konkapot and Umpachene are revered by the tribe. Norman Rockwell's last painting before his death depicts his fanciful vision of Konkapot meeting with missionary John Sergeant.

Jehoiakim Shawenon was not a sachem like Konkapot and Umpachene. He was chosen for this book as an iconic representative of "regular" tribe members, one of many unsung heroes. Young Shawenon was first mentioned in the notes of Stockbridge missionary Rev. John Sergeant. He is described as a bright Indian boy who wished to learn to read. As an adult, Shawenon was strongly connected with the land of present-day North Egremont and a big chunk of Alford. Circumstantial evidence suggests he may have lived near here as a young boy before moving to Stockbridge. Early deeds for property in the

Mohican Shawenon
Shawenon looks out at Prospect Lake in Egremont. (Painting by David Vosburgh.)

Egremont and Alford areas make references to "Shawenon land." His name comes up dozens of times in the earliest Egremont and Alford Proprietors Records.

Shawenon served as "Fence Viewer," an important town official responsible for determining and monitoring property lines. He was one of the original Indian proprietors of Stockbridge and owned 50 acres in the town. Shawenon was probably a counselor or advisor for the tribe, what they called "a principal man." He signed a number of petitions sent to Boston and sold some of his lands at various times, including five acres to Rev. Jonathan Edwards in 1754. He died around 1772. Shawenon's name lives on today as the name of a corporate communications business in Alford, and as a local history book, *Eye of Shawenon*.

Over time, trickery and legal maneuvers were used by the white settlers to separate the Stockbridge Indians from their land. Yet, tribe members voluntarily served as American soldiers and patriots during the Revolutionary War. Despite the good will, honesty, and patience exhibited by the Stockbridge Indians toward their neighbors, they were generally treated poorly at home and were later "encouraged" to relocate to New York State, and eventually to Wisconsin.

John Sergeant, Timothy Woodbridge, and Jonathan Edwards

In the early decades of the 18th century, Colonial leaders in Boston initiated a plan that they believed would please God. They hoped to establish English settlements and civilization in a wilderness now known as the Southern Berkshires, and, at the same time, convert the local Indians to Christianity and an English way of life. Rev. John Sergeant (1710–1749), a recent Yale graduate, was recruited to establish a Christian mission in South Berkshire for the Mohican Native Americans, also known as the Housatonnuck Indians. Sergeant was deeply committed to his task. Although not particularly open-minded to Indian beliefs and culture, he was protective of the Mohicans. Timothy Woodbridge (1709–1774) was hired as an assistant minister and schoolteacher.

When Sergeant began his work, most of the Mohicans lived in two separate villages. To simplify the daunting task facing Sergeant and Woodbridge—religious conversion and "civilizing" education—it was proposed that a single township be granted to the mission. The entire tribe could live together and attend the same church and school. Of course, this conveniently freed up more land for white settlement and helped serve as an organized buffer against the all-too-real threat of French and Iroquois confederation aggression.

The new township, which was to become Stockbridge, was first called Indian Town. It was settled in the spring of 1736 and, most important, was owned by the Mohicans. Only a few English families were given land titles in the village. It was their "job" to assistant Sergeant and to serve as living examples of an English way of life. One of these families, the Williams clan, was among the most influential families in the Connecticut River Valley. Not long after their arrival, Sergeant married Abigail, one of the Williams daughters.

In addition to the small school established for the Stockbridge Indians, Sergeant and Woodbridge set out to create a boarding school for young Native Americans, particularly the Iroquois, whose member tribes often sided with the French in their ongoing conflict with the English. The Stockbridge Indian

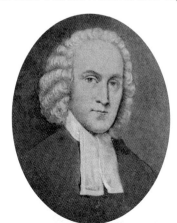

Jonathan Edwards
(Photograph courtesy of BerkshireArchive.com.)

mission, although on the frontier, was thus part of a larger plan by the English to improve relations and build alliances with hostile tribes.

Progress was slow with the boarding school, complicated by the death of Reverend Sergeant in 1749. He was only 39 years old. This was the beginning of the end for Mohican control of their town. Stockbridge went without a resident minister for two years, with Timothy Woodbridge overseeing the mission. In 1751, the seeds of conflict were sown between the Woodbridge and Williams families, when the prominent but controversial theologian Rev. Jonathan Edwards (1703–1758) was recruited (with support from Woodbridge) to take over the Stockbridge Mission. Meanwhile, the widow Abigail Sergeant, always a Williams at heart, married Joseph Dwight. Together, they continued the boarding-school plans for Native American children, this time adding financial gain to the missionary venue.

Jonathan Edwards was appalled by the graft and corruption—usually at the Mohicans' expense—associated with certain aspects of the town and the school. He grew to care about, and strongly support, the Mohicans. Thus, he and ally Woodbridge became enmeshed in an escalating dispute against the Williams and Dwight clan. It is impossible to know the fate of the Stockbridge Indians had Edwards remained as minister longer. Sadly, his destiny would take an unfortunate turn. Aaron Burr, president of the College of New Jersey (now Princeton University) had recently died, and Edwards was reluctantly persuaded to replace him. (Burr was married to Edwards's daughter.) Shortly thereafter, Edwards, an advocate of smallpox inoculations, decided to get inoculated himself. Unfortunately, he died of complications from the injection in 1758. Other family members died shortly thereafter. This left future vice president of the United States, young Aaron Burr Jr., to be raised by Edwards's son Timothy (both of whom also lived for a time among the Indians in Stockbridge).

Woodbridge remained in Stockbridge, becoming a judge, colony legislator, and superintendent of Indian affairs. During this time, he observed the Williams family and others grow wealthy, partially through the acquisition and sale of Indian lands. Woodbridge determined that he, too, was entitled to more than survival wages. He used his considerable talent and knowledge to improve his financial lot in life via numerous Indian land sales near and far.

As the early fire of independence was being fanned across the colony, the British military governor of Massachusetts, Thomas Gage, with King George's approval, chose Woodbridge as a member of the Governor's Council, an immensely powerful and prestigious position. But Woodbridge was a patriot—he declined the offer. He died shortly thereafter, in 1774.

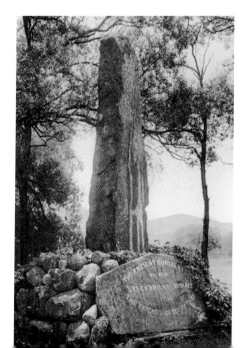

Stockbridge Indian Burial Grounds
In 1877, Mary Hopkins Goodrich, great-granddaughter of John Sergeant and founder of the Laurel Hill Association, erected this memorial at the site of the ancient Indian burial grounds in Stockbridge. (Photograph courtesy of BerkshireArchive.com.)

CHAPTER ONE

The Top Ten

Do not go where the path may lead,
go instead where there is no path and leave a trail.

—Ralph Waldo Emerson

An informal poll was taken among several local historians. About 15 names eventually appeared at the top of the list of "Most Accomplished Legendary Locals of the Southern Berkshires." What standards were applied for inclusion on this exclusive "Top Ten" list? First, the person must be deceased, and second, the person must have achieved national or international significance. Did he or she achieve success while living in the Berkshires? Not necessarily.

Not everyone agreed on the 10 entries, so tough, and occasionally arbitrary, choices had to be made. It was suggested that the controversy of such a list be avoided altogether, but what fun is that? Let us stir the pot and debate it! Here they are, in no particular order.

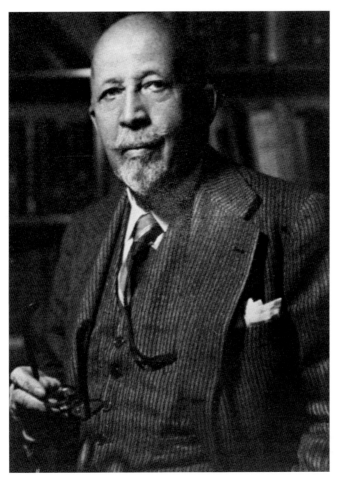

William Edward Burghardt Du Bois

Civil rights pioneer, prolific author, editor, and visionary W.E.B. Du Bois (1868–1963) was born and raised in Great Barrington. As a teenager, he wrote for area newspapers and worked as a timekeeper during the construction of opulent Searles Castle.

Du Bois (pronounced doo-BOYZ) was a very bright youngster, growing up rather poor, but in a racially tolerant community. Teachers and school administrators encouraged his studies. Local residents raised money to pay his college tuition. After graduating from Fisk University, Du Bois became the first African American to earn a doctorate at Harvard. He began his career as a professor of history, sociology, and economics at Atlanta University.

Du Bois was one of the cofounders of the National Association for the Advancement of Colored People (NAACP). He rose to national prominence as the leader of the Niagara Movement, a group of African American activists. In his role as editor of the NAACP's magazine, *The Crisis*, he published many influential articles. Du Bois's collection of essays, *The Souls of Black Folks*, was a seminal work in African American literature.

Du Bois spent the final years of his long, productive life in Ghana, Africa, working on an encyclopedia of the African experience. His health declined while in Ghana, and he died in 1963 at the age of 95. A day after his death, at the March on Washington, Du Bois was honored and remembered. The Civil Rights Act of 1964, which embodied many of the reforms Du Bois had campaigned for his entire life, was enacted one year after his death.

Du Bois had fond memories of his hometown and returned to Great Barrington many times. At a high school reunion, he spoke out against the pollution of the Housatonic River, proving to be ahead of his time in environmental awareness.

Great Barrington was slow to honor Du Bois, after being so supportive during his youth. The local historical society installed a memorial plaque at his birth site on Church Street in 1994. Controversy erupted in 2004 when an effort to name a new school after Du Bois was voted down. In recent years, signs have been placed on major highways into town announcing Great Barrington as the birthplace of Du Bois. The site where young Du Bois lived at his grandfather's small farmhouse (no longer standing) on Route 23 is now a National Historic Landmark. The Du Bois Center opened in 2006 to honor the civil rights pioneer. Located on South Main Street, it abuts the Mahaiwe Cemetery, where Du Bois buried his son Burghardt, first wife, Nina, and daughter Yolande. (Photograph courtesy of Great Barrington Historical Society.)

Elizabeth "Mumbet" Freeman

Earlier known simply as Bett and later formally called Elizabeth Freeman, Elizabeth "Mumbet" Freeman instigated an important trial that led to the abolition of slavery in Massachusetts. Bett (c. 1742–1829) was born into slavery at the Hogeboom farm near Hudson, New York. When Hogeboom's daughter Hannah married John Ashley of Sheffield, Hogeboom gave Bett to them. She remained with the Ashleys until 1781, during which time she married and had a child, Betsy. Her husband never returned from service in the Revolutionary War.

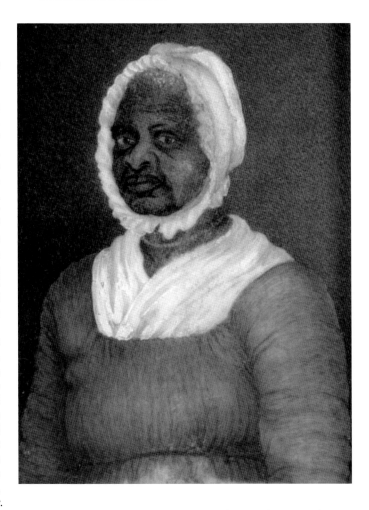

Throughout her life, Mumbet exhibited sturdy self-esteem. In 1780, she came into conflict with Hannah Ashley when the slaveholder attempted to strike Betsy with a hot fireplace shovel. Bett shielded her daughter and received a deep wound in her arm. She later displayed her injury to visitors as a badge of honor, much to the dismay of Ashley.

Soon after the Revolutionary War, Bett overheard John Ashley and his colleagues discussing the new Massachusetts constitution: "All men are born free and equal, and have certain natural, essential, and unalienable rights." The brave woman approached local lawyer Theodore Sedgwick and asked, "I heard that paper read yesterday, that says, all men are created equal, and that every man has a right to freedom. I'm not a dumb critter; won't the law give me my freedom?" Sedgwick accepted her challenge, took her case to court, won the suit, and, after similar cases were upheld by the Massachusetts Supreme Court, slavery was outlawed in the state.

After the ruling, Bett took the name Elizabeth Freeman. Although John Ashley asked her to return to his home, she decided to work in Sedgwick's household as senior servant and governess to the Sedgwick children (including novelist Catharine Sedgwick), who lovingly called her Mumbet. Freeman eventually bought her own home. She was recognized as a skillful midwife and nurse. When she died in 1829, Mumbet was buried within the prominent Sedgwick family plot in Stockbridge.

Mumbet was quoted as saying, "Any time, any time while I was a slave, if one minute's freedom had been offered to me, and I had been told I must die at the end of that minute, I would have taken it—just to stand one minute on God's airth [sic] a free woman— I would." (Photograph courtesy of Massachusetts Historical Society.)

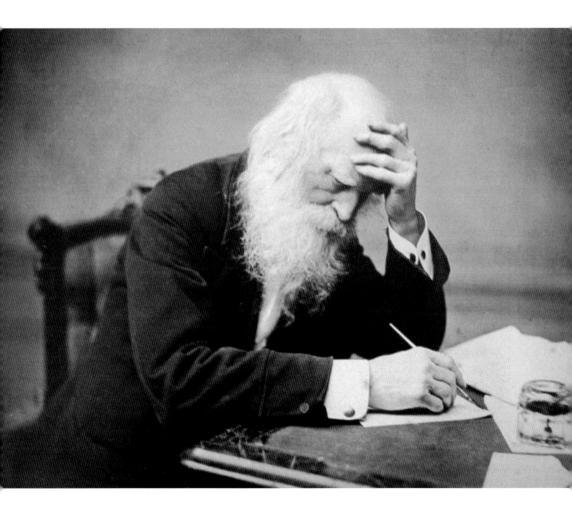

William Cullen Bryant

Until W.E.B. Du Bois was elevated into first place, William Cullen Bryant (1794–1878) was arguably the most celebrated person associated with Great Barrington. Bryant was a poet, lawyer, journalist, and longtime editor of the *New York Evening Post*. Born in the Berkshires, Bryant attended Williams College and was admitted to the bar in 1815. The poet-lawyer arrived in Great Barrington in 1816, a virtual unknown. While here, he practiced law, explored the countryside, and served as town clerk, justice of the peace, hog reeve, and school committeeman. A nature lover, Bryant experienced a different kind of love after meeting the fetching Frances Fairchild of Alford. They were married in 1821.

Although Bryant reveled in his explorations of the Southern Berkshire countryside, he had no love for the residents of Great Barrington. In 1825, he wrote a friend, "my residence in Great Barrington, in consequence of innumerable quarrels and factions which were springing up every day among an extremely excitable and not very enlightened population, had become quite disagreeable to me. It cost me more pain and perplexity than it was worth to live on friendly terms with my neighbors; and, not having, as I flatter myself, any great taste for contention, I made up my mind to get out of it as soon as I could and come to this great city [New York], where, if it was my lot to starve, I might starve peaceably and quietly." He then wrote to his wife, referencing "those miserable feuds and wranglings that make Great Barrington an unpleasant residence."

Bryant's affair with Great Barrington was truly a love-hate relationship. He enjoyed sneaking out of his office and seeking solitude at his favorite riverbank or mountaintop. He wrote a number of his best-loved poems based on South Berkshire settings, including "Green River" and "Monument Mountain." As one biographer wrote, "Bryant's poetry is tender and graceful, pervaded by a contemplative melancholy, and a love of solitude and the silence of the woods."

With help from the well-connected Sedgwick family of Stockbridge, Bryant moved to New York City, where, in 1825, he was named editor of two small literary publications. A few years later, he was made editor-in-chief (and part owner) of the *New-York Evening Post*. He remained at the newspaper's helm for half a century. Under his tutelage, the *Evening Post* earned him a fortune and offered the means to exercise considerable political power and influence—locally, regionally, and nationally.

Bryant remained in good health well into his 80s. A "Ripley's Believe It or Not" newspaper column once noted that "the great newspaper editor daily lifted dumbbells, walked three miles, ran up ten flights of stairs and chinned himself—all before work." He died in 1878 after an accidental fall in Central Park.

During the years that followed, Great Barrington did not forget him. Buildings, a grammar school, and even a mountain were named after him. For decades, local students were required to memorize and recite his most famous poem, "Thanatopsis." Martin Luther King Jr. quoted Bryant in his speech entitled "Give Us the Ballot," when he said, "Truth crushed to earth will rise again." (Photograph courtesy of Great Barrington Historical Society.)

Norman Rockwell

Legendary and prolific illustrator Norman Rockwell (1894–1978) is considered by many to be the most famous American artist of all time. Part of his genius was his ability to tell a story via canvas and color. "I paint life as I would like it to be," Rockwell once said. Idealistic and innocent, his paintings often evoke the hopes and aspirations of the viewer. According to filmmaker Steven Spielberg, "Rockwell painted the American dream—better than anyone."

Rockwell was a hugely popular painter who was quietly proud of his work. Yet, he modestly considered himself a commercial illustrator, rather than a "true artist." Aware of critics' unwillingness to recognize his paintings as art, he harbored some insecurity. But his ability to create visual stories that expressed the aspirations and memories of America actually helped to clarify the nation's vision.

After graduating from art school, 19-year-old Rockwell found immediate work as the art editor for *Boy's Life* magazine. By 1916, he had created his first of 317 memorable *Saturday Evening Post* covers. That same year, Rockwell married his first wife, Irene O'Connor. The couple divorced in 1930. Depressed, he moved California. While there, he met and married schoolteacher Mary Barstow, then returned to New York. The couple had three children, Jarvis, Thomas, and Peter, settling first in New Rochelle, New York, and then in Arlington, Vermont.

In 1953, the family moved to Stockbridge, Massachusetts, where Rockwell would spend the rest of his life. Following his wife's death in 1959, Rockwell married a third time, to Molly Punderson, a retired teacher. With Molly's encouragement, Rockwell began painting covers for *Look* magazine. His paintings had previously dealt with a utopian vision of the country, but now he turned more of his attention to social issues. Much of his work centered on themes concerning poverty, civil rights, and space exploration. During his long career, Rockwell was also commissioned to paint the portraits for Presidents Eisenhower, Kennedy, Johnson, and Nixon. One of his last works was a portrait of Stockbridge Indian chief Konkapot and Rev. John Sergeant, both featured in this book.

Beloved in Stockbridge, Rockwell and his wife would often be seen riding their bicycles around town. His friends and neighbors served as models for his paintings. In 1977, one year before his death, Rockwell was awarded the Presidential Medal of Freedom by Pres. Jimmy Carter. He is shown here celebrating his 80th birthday. Rockwell died at his home in Stockbridge in the autumn of 1978. He was 84 year old.

Today, the Norman Rockwell Museum in Stockbridge, under the guidance of visionary Laurie Norton Moffatt, houses the world's most significant public collection of Rockwell's work. (Photograph by Eileen Mooney.)

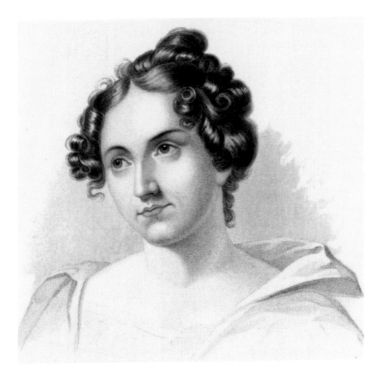

Catharine Sedgwick

Catharine Sedgwick (1789–1867), born in Stockbridge, was a hugely popular author. Her mother was Pamela Dwight of the prominent Dwight family, daughter of Gen. Joseph Dwight and granddaughter of Ephraim Williams, a founder of Williams College. Her father was Theodore Sedgwick, a prosperous lawyer (see page 28).

As a child, Sedgwick was cared for by Mumbet (Elizabeth Freeman), a former slave whose freedom Theodore Sedgwick helped gain by arguing her case in court (see page 13). After completing her schooling in Boston, Sedgwick returned to the Berkshires to head a school in Lenox. She converted from strict Calvinism to progressive Unitarianism, which led her to write about religious intolerance. Her evolving views on religion further inspired her to write her first novel, A New-England Tale.

Sedgwick became one of the most notable female novelists of her time. Her books found critical and commercial success. The central figures in Sedgwick's novels are women, often noted for their independence. Her novels were widely read from the 1820s to the 1850s, and she also earned income by writing short stories for a variety of periodicals. The subjects of her writing included the American Revolution, Puritan oppressiveness, intermarriage between races, and the struggles faced by working women trying to achieve independence. Sedgwick created spirited heroines who refused to conform to the expected conduct of women at the time. Her writings often showed tolerance for minority groups. The hero of her first novel was a Quaker in conflict with Puritan beliefs. Another book examined the psychological pressures within a Shaker community. The novel Hope Leslie shows an understanding of Native American traditions, based partly on her research into Indian customs.

Choosing to remain unwed throughout her life, Sedgwick turned down several marriage proposals. Although generally supportive of the institution of marriage, in her final book, Married or Single, she offered the bold notion that women should not marry if it meant losing their self-respect.

By the end of the 19th century, Sedgwick's books and writing were dismissed by critics and were forgotten by readers. But a renewed interest in the author's work, and an appreciation for her contributions to American literature, began in the 1960s as feminist scholars began to reevaluate women's contributions to literature. Today, via modern reprints and electronic books, Sedgwick's writings are again appreciated and enjoyed. (Illustration courtesy of BerkshireArchive.com.)

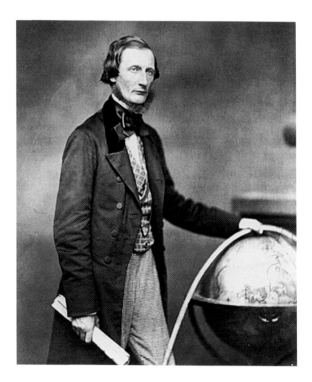

Cyrus Field

The Field clan of Stockbridge was an amazing family of overachievers. Cyrus Field (1819–1892) was one of 10 children of Rev. David Dudley Field, four of whom, like their father, were recognized in the *Dictionary of American Biography*. No doubt, all of the Fields are local legends, but Cyrus is of special note.

The original "Larry the Cable Guy" (but with class), Cyrus Field was the father of the transatlantic cable. He was a bright businessman who recognized the commercial and political possibilities of connecting Europe and North America via a communications cable. Persistent and optimistic, he wrestled with the project for over a decade as he encouraged international monetary support in Europe and America.

After securing financing in England and backing from the American and British governments, Field's Atlantic Telegraph Company began laying the first telegraph cable in 1857 along a relatively shallow submarine plateau between Ireland and Newfoundland. After several failed attempts, Field finally made the connection. His cable was officially activated in August 1858, when Queen Victoria sent US president James Buchanan a message in Morse code. Celebrations erupted in England, Canada, and the United States. A commemorative fireworks display set New York's city hall on fire. Tiffany & Company sold excess pieces of the cable as souvenirs. Field returned to a triumphant homecoming with a gala reception honoring the Berkshire boy who made good.

But the cheering stopped when the cable failed several weeks later. The press turned against him, and Field was vilified. But he would not abandon his dream. The US Civil War delayed the cable project, but Field set to work convincing investors to stay with him. After another failed attempt in 1865, the second transatlantic cable was successfully laid in 1866. Communications between Europe and America that previously took weeks could now be made in mere minutes. Field, again hailed as a hero, was given a gold medal by Congress. Sheet music was written in his honor, and a cigar box featured his likeness. The village of Field, British Columbia, was named in his honor, as was a mountain peak and Cyrus Field Road in Irvington, New York (where he died). The Westchester County village of Ardsley, New York, was named after Field's ancestral family's home in Great Britain.

Unfortunately, bad investments on Wall Street left Field bankrupt at the end of his life. The epitaph on his Stockbridge tombstone reads, "Cyrus West Field. To whose courage, energy and perseverance, the world owes the Atlantic telegraph." (Photograph courtesy of BerkshireArchive.com.)

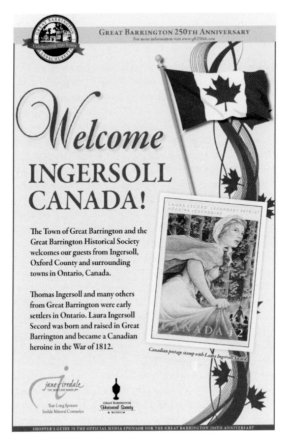

GREAT BARRINGTON 250TH ANNIVERSARY
For more information visit www.gb250th.com

Welcome
INGERSOLL CANADA!

The Town of Great Barrington and the Great Barrington Historical Society welcomes our guests from Ingersoll, Oxford County and surrounding towns in Ontario, Canada.

Thomas Ingersoll and many others from Great Barrington were early settlers in Ontario. Laura Ingersoll Secord was born and raised in Great Barrington and became a Canadian heroine in the War of 1812.

Canadian postage stamp with Laura Ingersoll Secord

jane iredale
THE SKIN CARE MAKEUP

Year-Long Sponsor
Iredale Mineral Cosmetics

GREAT BARRINGTON
Historical Society
& MUSEUM

SHOPPER'S GUIDE IS THE OFFICIAL MEDIA SPONSOR FOR THE GREAT BARRINGTON 250TH ANNIVERSARY

Laura Ingersoll Secord

Laura Ingersoll Secord (1775–1868) was a Canadian heroine of the War of 1812. She was born and raised in a Great Barrington home that stood on the site of the Mason Library. A small bronze plaque (opposite page), placed on the library lawn by the Great Barrington Historic District Commission, briefly acknowledges her accomplishments. Laura was the daughter of Thomas and Elizabeth (Dewey) Ingersoll. Her father was self-employed as a hatter, but he had other business interests, including a gristmill. He also served as town constable and tax collector.

With the outbreak of the American Revolutionary War, Thomas Ingersoll enlisted in the militia, serving as a second lieutenant and later as a captain. While British Empire loyalists (Tories) fled to New York and Canada, Ingersoll served his country as a patriot until the end of the war. When Shays' Rebellion broke out in 1786, Ingersoll again answered the call, earning the rank of major. His business interests suffered during the war, and the weak postwar economy did not help matters. Then, his young wife died suddenly, leaving eight-year-old Laura to care for her three little sisters. Thomas Ingersoll married again, but his second wife passed away when Laura was about 14 years old.

By the time Ingersoll married a third time, perhaps he was ready to leave sad memories behind. Or, perhaps his business still hadn't recovered. For whatever reasons, he decided to move to Upper Canada, encouraged by the promise of dirt-cheap land. Upon successful application for a land grant, Ingersoll and several associates, including Great Barrington's Episcopal priest Gideon Bostwick, were granted an entire township with thousands of acres. Among his new neighbors were Canadian-born residents, other US transplants, and numerous Tory refugees. Because of this, some Berkshire residents believe to this day that the Ingersolls were Tories and traitors. This, however, is not true.

Today, several Canadian provinces have schools named after Laura Ingersoll Secord. Numerous monuments in Canada honor her. She has been featured on two postage stamps and on several coins.

Secord's former Queenston, Ontario, home is a popular tourist site. Numerous books, songs, plays, and even a comic book tell of her bravery. And a Laura Secord brand of chocolate is the most popular confection in Canada.

Why is Laura Secord so beloved in Canada, yet sometimes misunderstood in Great Barrington? The answer is complex. She moved to Upper Canada (now Ontario) at age 20 with her father and siblings. After her father founded what is now Ingersoll, Ontario. Laura remained in the Niagara area where she met and married James Secord.

In 1812, partially as a result of attacks on American ships by the British Navy, the United States declared war on Great Britain. Part of the war strategy was to annex Canada and remove the British presence from North America. The Niagara district was invaded by American forces in October 1812. At the time, James Secord was serving under legendary British general Isaac Brock, who was killed in the attack on Queenston Heights, near Secord's home. James Secord was among those who helped carry away Brock's body. Secord himself was severely wounded in the leg and shoulder during the battle. Laura heard of his predicament and rushed to his side. When the Secords arrived home, they found their house looted by retreating American soldiers. Laura spent many months nursing her wounded husband back to health.

The following June, a small band of American militiamen, who had been harassing local Queenston residents, demanded food at the Secord household. Laura politely provided supper and spirits to the soldiers. The captain in charge began drinking and bragging about a plan of an impending attack on the British forces of Lt. James FitzGibbon. Upon hearing the plan, the Secords knew that FitzGibbon must be warned. Still recovering from his injuries, James Secord could not attempt the journey. Despite the danger, Laura decided she would warn FitzGibbon. Her journey was a treacherous and circuitous route of nearly 20 miles. Fearing discovery by enemy patrols, Laura Secord kept off the main roads, trekking through thick woods and dismal swamps. The dangers were many. Wolves and snakes were common in the area at the time. And a woman walking alone beyond enemy lines risked being arrested or worse.

Overcoming scorching heat and oppressive humidity, Laura pushed onward. Near the hamlet of Beaver Dams, she found herself surrounded by Indians. Luckily, these Canadian Indians were allies of the British. Upon hearing her news, they accompanied her to FitzGibbon's headquarters, where she delivered her vital message. As a result, FitzGibbon later surprised and captured the enemy invaders at the Battle of Beaver Dams.

It was not until 1860, when Secord was 85 years old, that she finally received recognition for her bravery. She died in 1868 at the age of 93 and was buried in Drummond Hill Cemetery at Niagara Falls. In 2003, Canada declared Laura Secord a "Person of National Historic Significance."

It is important to note that Laura Ingersoll Secord was no traitor to the United States. She was a British subject and a resident of Canada for 18 years when she made her brave journey. Her actions were not motivated by profit or glory. She and her family suffered in silence for years after the war, and they struggled financially for the rest of their lives.

Laura Secord deserves to be remembered and honored by her hometown as the daughter of a patriot, a courageous Canadian heroine who saved her husband's life and risked her own life to protect her country from invasion. As a result of her actions, many lives were saved, including hundreds of American lives. (Photographs courtesy of the author.)

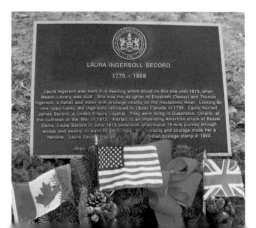

Daniel Chester French

One of the most prominent monumental sculptors of the late 19th and early 20th centuries, Daniel Chester French (1850–1931) is probably best known for his statues of two great American icons: the *Minute Man*, in Concord, Massachusetts; and the seated *Abraham Lincoln* at the Lincoln Memorial in Washington, DC.

Born in Exeter, New Hampshire, French moved while a teenager with his family to Concord. He was a neighbor and friend of Ralph Waldo Emerson and the legendary Alcott family. French's first "claim to fame" was his creation of the *Minute Man* statue, commissioned by the town of Concord and unveiled in 1875 on the 100th anniversary of the Battle of Lexington and Concord. He established a studio in Washington, DC, moving later to Boston and then to New York City. His reputation grew with the work he exhibited at Chicago's World Columbian Exposition of 1893.

French was at the center of the American Renaissance, a movement in which artists, architects, scholars, craftsmen, and civic leaders collaborated. Drawing inspiration from the European Renaissance and America's Colonial past, the grand public buildings, monuments, and parks created by French and his artistic comrades shaped the nation's cultural landscape.

A disciplined, prolific sculptor, French produced far too many wonderful works to list here. In collaboration with equestrian sculptor Edward Clark Potter, he modeled the *George Washington* statue, presented to France by the Daughters of the American Revolution; the *Ulysses S. Grant* statue in Fairmount Park, Philadelphia; and the *General Joseph Hooker* statue in Boston.

French was an innovator, often combining portrait and allegorical concepts into architectural settings. The Melvin Memorial in Concord is considered by many experts to be his finest war monument. A tribute to three brothers killed during the US Civil War, it features an angel emerging from a block of marble. Ever versatile, some of French's most illustrious sculpture was executed in conjunction with leading American architects of the City Beautiful movement.

Seeking additional studio space and a change of scenery, French bought an old farm in the Glendale hamlet of Stockbridge. Building a cavernous studio and a 17-room Colonial Revival house with gardens, he transformed this rustic property into a lovely estate, joining the Gilded Age set that summered in the Berkshires. His studio featured a railroad handcar mounted on tracks, which allowed him to roll his work-in-progress outdoors to examine the effects of natural lighting. French loved Chesterwood, remarking to a New York reporter, "I spend six months of the year up there, that is heaven." Noted sculptor Henry Augustus Lukeman lived nearby.

French was one of the founders of the Berkshire Playhouse, which later became the Berkshire Theatre Festival. He passed away in Stockbridge at age 81. Chesterwood was given by his daughter, Margaret French Cresson, to the National Trust for Historic Preservation in 1969. Now a popular museum, it is located just down the street from the Norman Rockwell Museum. (Photograph courtesy of Chesterwood.)

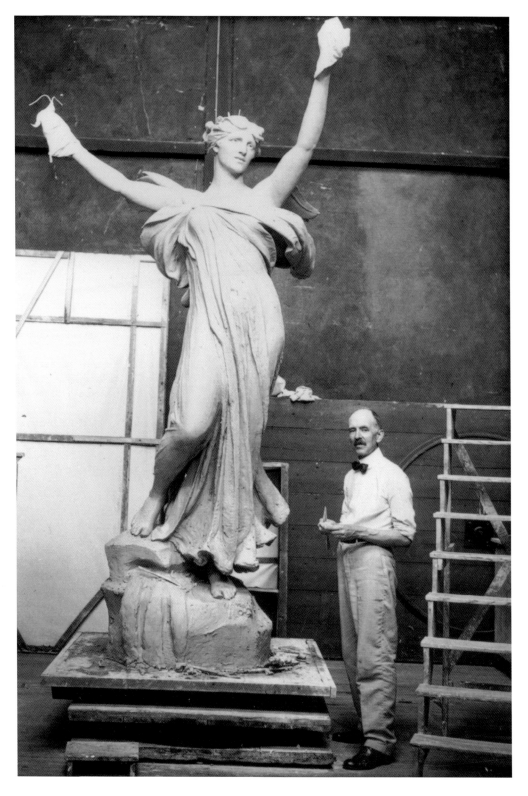

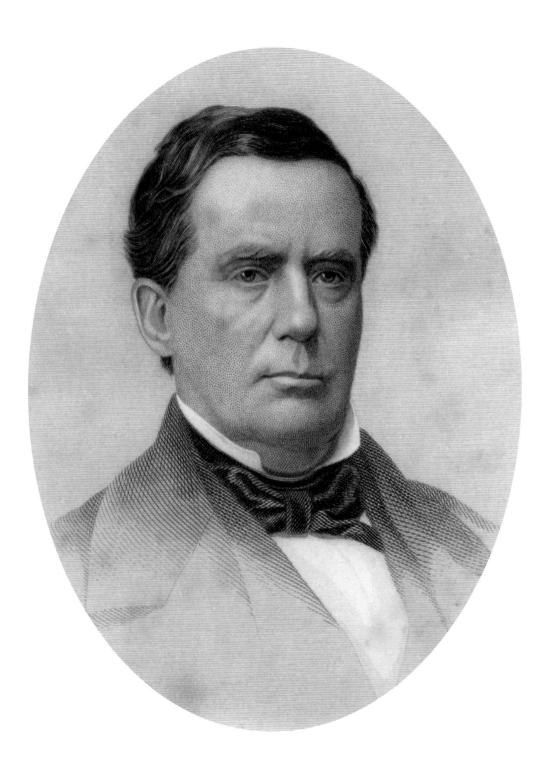

Anson Jones

Great Barrington history buffs enjoy asking the following trivia question: Who was the only person from South Berkshire to become president of a country? The answer: Anson Jones.

Jones (1798–1858) was a medical doctor, businessman, ambassador, congressman, and the fourth and last president of the Republic of Texas. He was born and raised in Great Barrington, and his earliest recollections were of that "pleasant little village in Berkshire county, on the banks of the Housatonic." He was the 13th of 14 children of Solomon and Sarah Strong Jones.

Jones's father fought at Bunker Hill during the Revolutionary War and witnessed British general Burgoyne's surrender at Saratoga. He was a poor tenant farmer and tanner who "was driven by economic necessity to move his numerous family . . . from one scrubby farm to another at frequent intervals." Young Jones attended a tiny school near the Lime Kiln section of Sheffield, and he later walked more than two miles to a schoolhouse at Egremont Plain. One friend of the family recalled that Jones was a bright boy who sometimes went ice fishing with his pals during the winter at Long Pond. While the other children's feet quickly got cold standing on the ice, Jones was smart enough to bring along a thick wooden board on which to stand, helping to insulate his feet from the ice.

The Jones family remained poor, and life was not easy for Anson. Despite the financial challenges and hard work, he must have retained some fond memories of Great Barrington. Many years later, he named his prosperous Texas ranch "Barrington."

Jones began an apprenticeship with a physician in Litchfield, Connecticut, and continued his studies in Utica, New York, where he lived with a brother. To earn money, he worked as a teacher. He later practiced medicine (rather unsuccessfully) in Philadelphia, Venezuela, and New Orleans. When Jones moved to Texas, he experienced two decades of accomplishment in a different line of work. What makes Jones's eventual success even more remarkable is that he probably suffered from crippling depression for a good part of his life. In 1836, he helped to create an independent nation, the Republic of Texas, and served in the Army as a surgeon. He married Mary McCrory in 1840, and they raised four children.

Jones held several governmental positions. He served as judge advocate general, then was elected to the Texas Legislature in 1837. He went to Washington, DC, as ambassador from Texas, meeting frequently with Pres. Martin Van Buren. He became the Texas secretary of state and was elected fourth president of the Republic of Texas in 1844, serving until the country was annexed to the United States in 1846. At that time, Jones delivered a speech that concluded with these words: "The final act in this great drama is now performed. The Republic of Texas is no more."

For a time, Jones retired to his ranch and wrote a book about the history of Texas. He lost a heartfelt bid to become a US senator, and in severe depression (and considerable pain from an earlier injury), Jones took his own life in 1858. Today, both a town and county in Texas are named after him, as are two schools. Southern Berkshire folks are proud to call him a native son. (Lithograph courtesy of BerkshireArchive.com.)

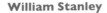

William Stanley

When one turns on a light or powers up a computer, one should think of William Stanley (1858–1916). The versatile inventor was granted 129 patents over his lifetime, covering a wide range of devices. One of them changed the world.

Until the 1880s, direct current (DC), of which Thomas Edison was a proponent, had a major shortcoming. This form of electrical transmission required wires of enormous thickness in order to distribute electricity over long distances. It just was not practical. William Stanley developed and refined the induction coil, a transformer that safely distributed alternating current (AC) electricity over long distances. An example of his transformer is inset at left.

Stanley's first job was as an electrician with one of the early manufacturers of telegraph keys and fire alarms. He designed one of the country's first electrical installations for a store in the commercial district of New York City. After inventor and industrialist George Westinghouse learned of Stanley's accomplishments, he hired him as chief engineer at his Pittsburgh factory. It was during this time that Stanley began work on the transformer.

Suffering from ill health, Stanley left Pittsburgh and moved to Great Barrington, a town with many family connections. He leased an old mill on Cottage Street and began his experiments. In 1886, after convincing dozens of Main Street merchants to sign up for his experimental plan of lighting, Stanley strung wires from the old factory across the Housatonic River to Main Street. The 500 volts of electricity produced at the factory were reduced to a safer, usable 100 volts by Stanley's transformers, located at each building where newly installed incandescent lamps had been placed. His system worked!

Stanley later moved to Pittsfield and established the Stanley Electric Manufacturing Company, which eventually merged into General Electric. The land on which the company once stood is now the site of the William Stanley Business Park. Stanley returned to Great Barrington in 1898 to organize Stanley Instrument Company, manufacturer of watt-hour meters. Here, he ran into problems with former employer George Westinghouse, who successfully sued for patent infringement. The indefatigable Stanley sold off the rights to several of his other patents to raise capital, and he began developing new products. Experimenting with ways to insulate a kitchen stove, Stanley created a Thermos-style vacuum container made of metal and unbreakable glass, which he called a Ferrostat bottle. Stanley Insulating began manufacturing these vacuum bottles, jugs, and carafes in various sizes. The ever-popular Stanley bottles are still made today on the West Coast.

Several plaques and monuments in Great Barrington recognize the contributions of William Stanley. He lit up the world with his brilliance. (William Stanley lithograph courtesy of Bernard Drew collection; transformer photograph courtesy of Great Barrington Historical Society.)

CHAPTER TWO

The Public Arena

*We can chart our future clearly and wisely
only when we know the path which has led to the present.*

—Adlai E. Stevenson

What motivates a person to a life of public service? It usually requires forfeiting one's privacy and enduring the judgment of others. How does one end up in the public eye? Perhaps it is a strong desire to serve, or simply being at the right place at the right time. Although a quest for power and control is occasionally a motivator, public service is generally a wish on the part of fortunate individuals to give back to their community. Hopefully, folks with such vision and courage will encourage and inspire others with the human potential for goodness.

There are countless individuals in our community, past and present, who have contributed locally, nationally, and internationally to enhance the human experience. Think of each person in this chapter as an iconic representative of many others in our community who are equally talented and respected. For example, when you read about radio personality Tom Jaworski, think also of his popular airwaves associate Nick Diller. When you spot the photograph of police chief Rick Wilcox, think also of retired Egremont chief Charles Seiger. Or when you discover that Gene Dellea has been town moderator in West Stockbridge for over 40 years, think about Great Barrington's longtime assessor Robert Guidi and distinguished town moderator Edward McCormick. When you read about veteran journalist Linda Ellerbee, remember also hard-working local news gatherers like the late John Mooney, as well as Eileen Mooney, Anastasia Stanmeyer, Seth Rogovoy, David Scribner, Derek Gentile, Anthony Prisendorf, and Donna Prisendorf. The list goes on and on.

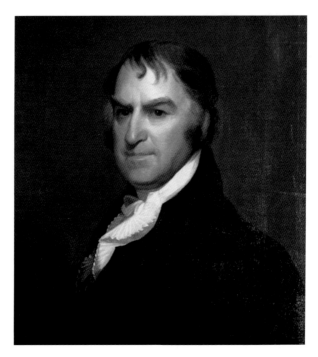

Theodore Sedgwick

Theodore Sedgwick (1746–1813) was arguably a man of puzzling contradictions. Feisty and opinionated, he fought in court to free a slave, yet opposed an agrarian uprising by poor farmers.

Sedgwick settled in Sheffield shortly after leaving Yale in 1763. He was one of the first Berkshire attorneys admitted to the Massachusetts Bar. Records from Berkshire County's Court of Common Pleas suggest he had a busy legal practice. But the escalating conflict between Great Britain and the American colonies became the focus of his life. Sedgwick, a staunch patriot, was also aristocratic, sometimes displaying little patience for the common man. In 1776, he howled his complaints to the Massachusetts Legislature when he heard that the "commoners" of Berkshire were gathering to read a radical new pamphlet, *Common Sense*, by Thomas Paine.

Sedgwick also objected when, several years after the War for Independence had ended, farmers and laborers broke the law by closing the courts to protest harsh Massachusetts postwar tax legislation. This protest grew into what has been called Shays' Rebellion. Once the uprising was suppressed, however, Sedgwick chose to represent several farmers accused of treason. At the same time, he was instrumental in the conviction for sedition of his old friend, Berkshire chief justice Dr. William Whiting, who supported the uprising. In Sedgwick's mind, the poor farmers did not know better. Whiting should have.

In 1781, at the Great Barrington courthouse, Sedgwick successfully defended Mumbet in a landmark case in which she won her freedom from slavery. In 1777, Sedgwick had bought a slave from a friend in Sheffield. But by 1781, he had changed his attitude, perhaps influenced by the new Massachusetts Constitution of 1780.

Prior to the ratification of the present US constitution in 1788, Sedgwick represented Massachusetts in the Confederation Congress. In the first US elections under the current constitution, Sedgwick was elected as Berkshire/Hampshire's first representative, serving as George Washington's strong advocate in Congress. In 1796, he was chosen senator from Massachusetts and was later named Speaker of the House of Representatives. He then served on the Massachusetts Supreme Judicial Court. He also continued practicing law in Stockbridge and trained law students, including, ironically, Mason Whiting, the son of Dr. Whiting, his old adversary. Sedgwick was patriarch to a long line of accomplished descendants, from his daughter, noted novelist Catharine Sedgwick, to award-winning actress Kyra Sedgwick. (Photograph courtesy of National Portrait Gallery, Smithsonian Institute.).

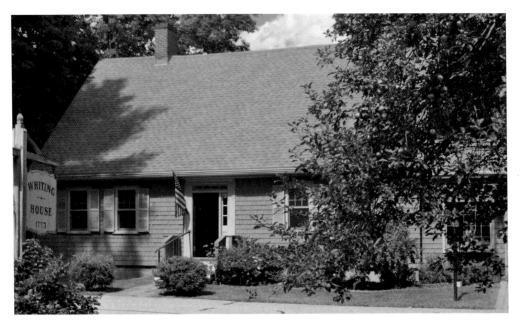

William Whiting

Dr. William Whiting (1730–1792) was born into a dynastic and influential Connecticut family. He received his medical training from a noted Connecticut physician, Dr. John Bulkeley (whose descendants still live in Mount Washington, Massachusetts).

Whiting moved to Great Barrington in 1765, built a thriving medical practice, and served as selectman and town moderator. In 1769, he published a pamphlet criticizing the religious tyranny of some of New England's Congregational preachers, including Great Barrington's pastor, Rev. Samuel Hopkins. His writing compared the church to the political and economic tyranny leveled on the colonies by Great Britain. When patriots across Massachusetts created their own Provincial Congress, Whiting was elected to all of its sessions. The versatile doctor also developed an expertise in making saltpeter. This key ingredient of gunpowder, essential for the war effort, was in critically short supply. Whiting directed its manufacture.

He later started a smallpox inoculation clinic, served on Great Barrington's Committee of Safety and Inspection, and was asked to help create the commonwealth's first constitution. About 1781, Whiting joined with 30 physicians to form the Massachusetts Medical Society. He was the only doctor from Western Massachusetts. He was also named the chief justice for Berkshire County, the most prestigious state appointment at the county level. He also presided over the landmark antislavery case involving Mumbet (Elizabeth Freeman).

As Americans wrestled with immense war debt and social upheaval, Whiting found himself in a predicament. Massachusetts government was controlled by an elite group centered in Boston. Whiting, who had hobnobbed with the best of them, greatly sympathized with the floundering middle class and the working poor. The economic challenges facing farmers and laborers struck home most forcefully as he volunteered his medical services to those jailed for debt, and he gained firsthand experience with social distress as chief justice.

When Shays' Rebellion erupted in 1786, Whiting took a leading role in supporting those fighting for legislative relief. Surprisingly, leaders such as John and Sam Adams seemed in vehement opposition to the plight of the downtrodden. Whiting became a target of their ire. He was convicted of sedition in 1787, fined, and removed as chief justice. Yet, he continued to be held in high esteem by his Berkshire neighbors, and he was elected to the state senate in 1788 to help carry out economic reforms.

Whiting's courage is still honored. In 2011, the Massachusetts Chapter of Trial Attorney Advocates created an annual award, the Dr. Whiting Judicial Courage Award. Whiting's 1773 house (pictured) has been moved twice and is presently home to the *Shopper's Guide* newspaper. (Photograph by the author.)

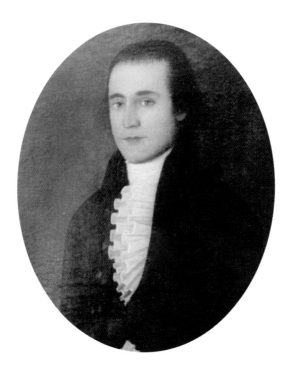

Barnabas Bidwell

The Bidwell House Museum in Monterey offers a remarkable opportunity to sample Berkshire life in the mid-to-late 1700s. Barnabas Bidwell (1763–1833), one of the first of his family to be born in the house, followed a path that carried him far beyond the Berkshires. Born in the midst of the American Revolution, Bidwell was the son of the town's first minister, Adonijah Bidwell. Young Bidwell enrolled in Yale and later began a law practice in Stockbridge under Theodore Sedgwick. A Federalist Party proponent, Sedgwick was often away serving as a US congressman and senator. Bidwell, however, became disenchanted with the Federalist Party, shifting his support to the Democratic-Republican Party and presidential candidate Thomas Jefferson. Following Jefferson's election, Bidwell was elected to Congress, where he quickly became Jefferson's most ardent supporter. In 1807, Bidwell left Congress to become the commonwealth's attorney general.

Bidwell's rise to national prominence continued at a brisk pace. Evidence suggests he was likely to be named to the US Supreme Court around 1810 by newly elected president James Madison. Then, the bottom fell out of Bidwell's career. As Berkshire County commissioner, Bidwell was accused of embezzlement. The post was a minor political appointment, managed by a subordinate who had just died. Bidwell considered the accusation political retaliation for abandoning the Federalist Party. Despite his impassioned claim of innocence, he chose an unorthodox way to avoid arrest and an ugly legal battle. His wife had recently died, and, feeling despondent, Bidwell and his young son, Marshall, quickly absconded to Kingston, Upper Canada, in 1810. At 46 years old, he was ready to create a new life as a Canadian. Bidwell began a school for boys in Kingston, befriended a number of political reformers, and, in 1821, was elected to Upper Canada's House of Representatives. His election caused a ferocious backlash by pro-British leaders in power. Bidwell's character was attacked, and he was booted from political office.

Marshall Bidwell, like his father, became a powerful political figure—and suffered a political fate eerily similar to that of Barnabas. Based on trumped-up political charges, Marshall was banished from Canada in the 1830s. He returned to the United States and became a successful lawyer in New York City.

To this day, Bidwell's embezzlement accusations and flight to Canada remain puzzling to historians. Bidwell repaid all missing monies, whether it was his fault or not. Based on testimonials made by Americans and Canadians who knew him well, Bidwell was an honorable and honest man. (Photograph courtesy of Bidwell House Museum.)

Justin Dewey

Justin Dewey III (1836–1900) was one of the Southern Berkshires' most prominent jurists. He was born in Alford, attended school in Great Barrington, and went to Williams College. He then studied law in Great Barrington and was admitted to the bar in 1860. Dewey practiced law in town for a quarter-century and was held in high esteem as a most competent and fair man. He was elected to the house of representatives and later the state senate. He was then appointed to the Massachusetts Superior Court in 1886. Already a local legend in Berkshire, Dewey became famous worldwide as a presiding judge at the infamous 1892 Lizzie Borden ax-murder trial in New Bedford. As the famous poem exclaimed, "Lizzie Borden took an axe / And gave her mother forty whacks. / When she saw what she had done, / she gave her father forty-one."

Judge Dewey was active in local affairs, serving on the school board and the library committee and as a bank director. He also served as a county commissioner, Congregational Church deacon, director of Berkshire Life Insurance Company, and a trustee of Williams College. (Photograph courtesy of Bernard Drew collection.)

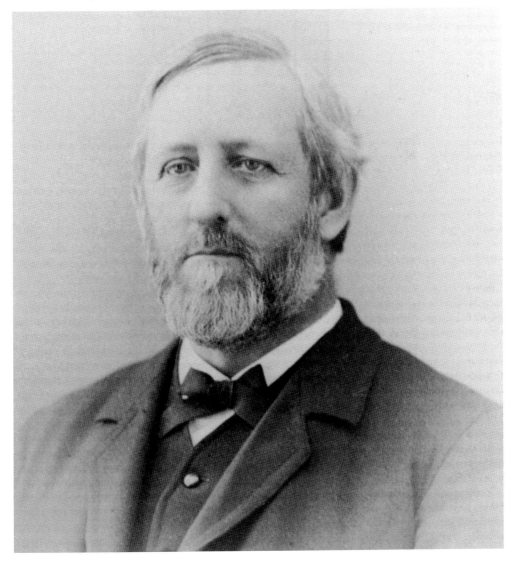

John Ashley

Col. John Ashley (1709–1802) was a Yale-educated lawyer, settler of Sheffield, wealthy landowner, businessman, and leader in the community. After he married his New York Dutch bride, Hannah Hogeboom, their home became the center of social, economic, and political life in South Berkshire County during the 18th century. It is now a museum operated by the Trustees of Reservations. It was here that the signing of the Sheffield Resolves took place. The petition against British tyranny and a manifesto for individual rights predated the Declaration of Independence by several years. Less than a decade later, Elizabeth "Mumbet" Freeman, who was enslaved in the Ashley House, sued for her freedom and helped end slavery in Massachusetts (see page 13). Ashley and his wife are buried in Sheffield's ancient Barnard cemetery, shown here. A close look at the photograph reveals a young girl playing hide-and-seek as she peeks out behind Ashley's tombstone. (Photograph courtesy of BerkshireArchive.com.)

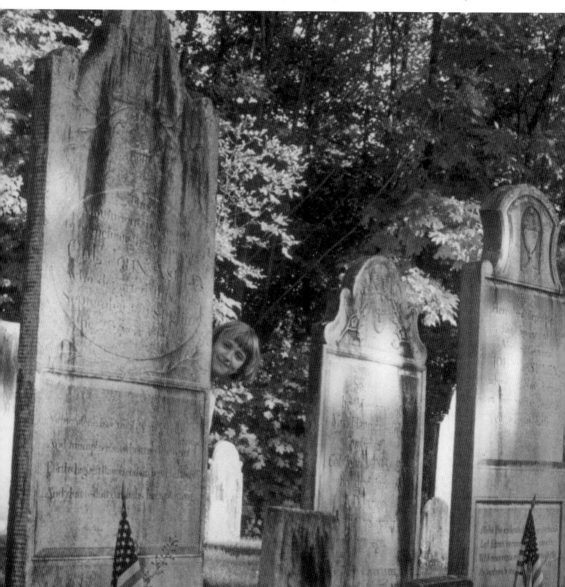

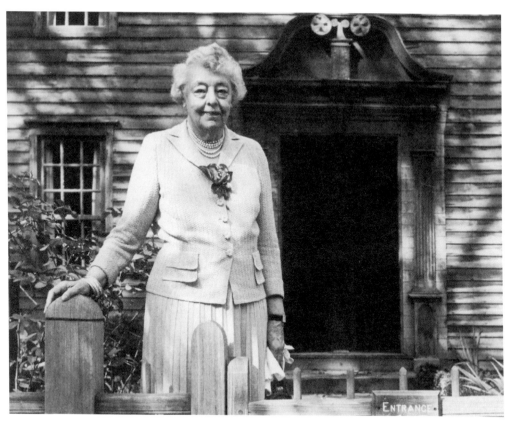

ENTRANCE

Joseph and Mabel Choate

Joseph Choate (1832–1917) was a prominent New York City lawyer and ambassador to the United Kingdom who summered at his grand Stockbridge "cottage," Naumkeag. Designed by the prestigious architectural firm of McKim, Mead & White, it features breathtaking gardens designed by Choate's daughter Mabel and noted landscape architect Fletcher Steele. Mabel summered here until 1958, when she bequeathed the house and its contents to the Trustees of Reservations. In 1926, Mabel Choate acquired property on the corner of Sergeant and Main Streets. She moved the home of Rev. John Sergeant—the first missionary to the Stockbridge Indians—to the site, thus creating the Mission House Museum. (Photograph of Mabel Choate by William Tague; photograph of Ambassador Choate courtesy of the Library of Congress.)

33

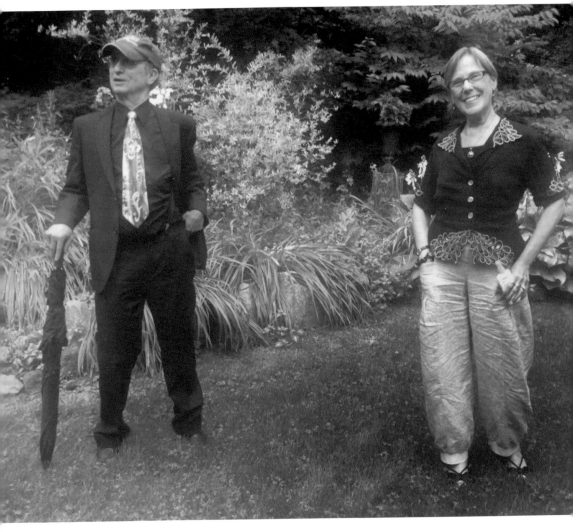

Alan and Roselle Chartock

The Chartocks, longtime Berkshire residents, are passionate about their community. Alan, the president of WAMC Northeast Public Radio, writes the *Berkshire Eagle*'s "I Publius" column and is the founder and publisher of the *Legislative Gazette*. He was a political science and communications professor for 40 years at SUNY New Paltz and SUNY Albany.

Roselle taught social studies for 15 years at Monument Mountain Regional High School, where she helped create the area's first Holocaust curriculum for high school students. She also designed and taught the school's first course on Berkshire history. She then spent 25 years as professor of education at the Massachusetts College of Liberal Arts. Roselle, a talented collage artist, is presently writing her fourth book. The Chartocks enjoy performing folk music as the Berkshire Ramblers. They have two grown children, Jonas and Sarah, as well as Murray, their Westie wonder dog. (Photograph by Diana Felber.)

Richard Watson Gilder

Richard Watson Gilder (1844–1909) was one of the foremost figures in New York literary society during the latter part of the 19th and the early 20th century. After serving as a soldier in the US Civil War, Gilder worked as a newspaper reporter and editor. He became an accomplished poet, book editor, and author. He cofounded the legendary children's magazine *St. Nicholas* and is perhaps best known as the innovative editor-in-chief of the influential *Century* magazine. Prominent friends who vacationed at his Tyringham home included Samuel Clemens (Mark Twain) and Pres. Grover Cleveland. Gilder was very involved and supportive of numerous civic improvement projects, educational groups, and public-service organizations. (Photograph courtesy of *Letters of Richard Watson Gilder* by Rosamond Gilder.)

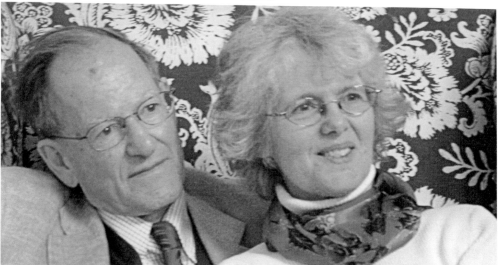

George and Cornelia Gilder

George Gilder, of Tyringham, is the great-grandson of Richard Gilder. He is a prominent economist, writer, speaker, political activist, and the cofounder of the Discovery Institute. He is also chairman of George Gilder Fund Management and host of the Gilder Telecosm Forum. In the 1960s, Gilder worked as a speechwriter for Nelson Rockefeller, George Romney, and Richard Nixon. He is the author of numerous books, including *Wealth and Poverty*, *The Spirit of Enterprise*, *Microcosm*, *Life After Television*, *Telecosm*, *The Silicon Eye*, and *The Israel Test*. He helped pioneer the formulation of supply-side economics and was Pres. Ronald Reagan's most frequently quoted living author. Gilder's wife, Cornelia "Nini" Brooke Gilder, is a well-known local historian and the author of several books, including *Houses of the Berkshires* and *Hawthorne's Lenox: The Tanglewood Circle*. (Photograph by Anne-Lee Gilder.)

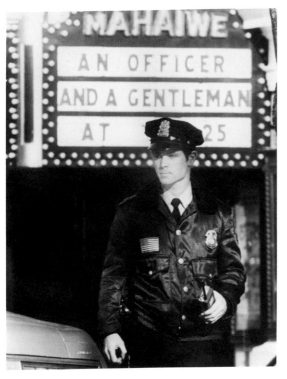

William Walsh and James McGarry

The Mahaiwe Theater marquee in the above photograph says it all. Bill Walsh is seen here in 1982, one year before he was appointed police chief in Great Barrington. He now ranks as the longest-tenured Berkshire County police chief presently on the job. Sheffield police chief James "Jim" McGarry (right) retired in 2012 after serving 41 years as head of the department, believed to be a statewide record. (Photographs by Donald Victor.)

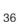

Eugene Dellea

Fairview Hospital president Eugene "Gene" Dellea of West Stockbridge got interested in politics at a young age. When he was 18, he served as acting student governor at the statehouse in Boston. A few years later, he was the youngest selectman ever elected in West Stockbridge. Dellea remains the longest-serving town moderator in the entire state. He has been active in numerous community and civic organizations for many years, and he was recently honored by the Southern Berkshire Chamber of Commerce as Business Person of the Year. Dellea was a manager of Sen. Robert Kennedy's presidential campaign in 1968, when the above photograph was taken. (Photographs courtesy of Gene Dellea.)

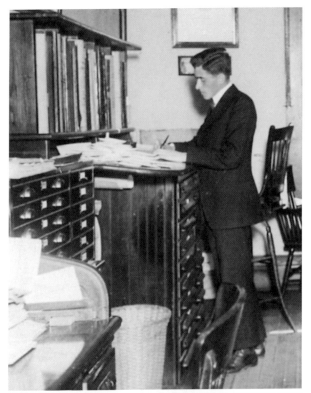

Robert K. Wheeler

Robert K. Wheeler (1892–1980) was arguably the most influential Southern Berkshire businessman and civic leader in the 20th century. President of Wheeler and Taylor Insurance and Realty Company for many years, he, at various times, also operated the Red Lion Inn in Stockbridge and the Berkshire Inn in Great Barrington. Wheeler served as a selectman, finance committee member, and president of the chamber of commerce and the rotary club. He was also active on the board of Fairview Hospital and Simon's Rock college. He was involved in many major real-estate ventures throughout South County, including developments in South Egremont and the Great Barrington Airport. At one time, he was part owner of Searles Castle and Pioneer Credit Corporation. Wheeler, a behind-the-scenes operator, has been described by colleagues as a visionary and quiet benefactor to many people. (Photographs courtesy of Great Barrington Historical Society.)

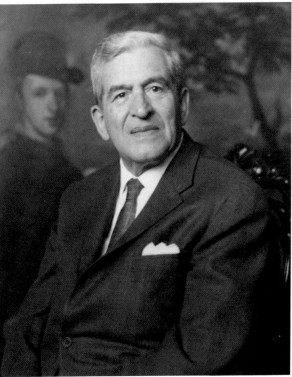

Edward Carroll

Edward Carroll (1911–1979) owned the Great Barrington Fair from 1940 to 1976. He is shown here flanked by bicycle prizewinners Shelia Sullivan and Bobby Reid around 1960. The fair began in 1842 and became a big part of the Southern Berkshire economy. Record numbers attended the fair during Carroll's tenure, and he was well liked in the community. Hundreds of thousands of people traveled to the fairgrounds every autumn, especially after sulky races were replaced by pari-mutuel wagering on horse racing. The owner was perhaps most famous for his "Carroll weather," as the fair benefited from sunny conditions 36 years in a row. After Carroll sold the fair in 1976, it rained more days than it was sunny. (Photograph by Marie Tassone.)

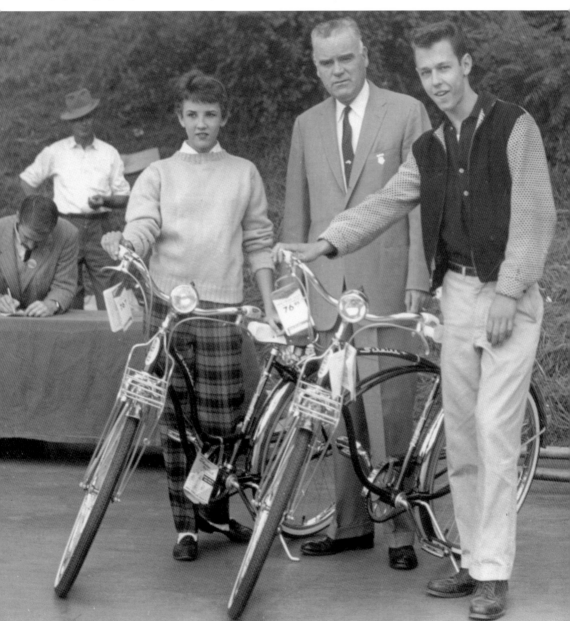

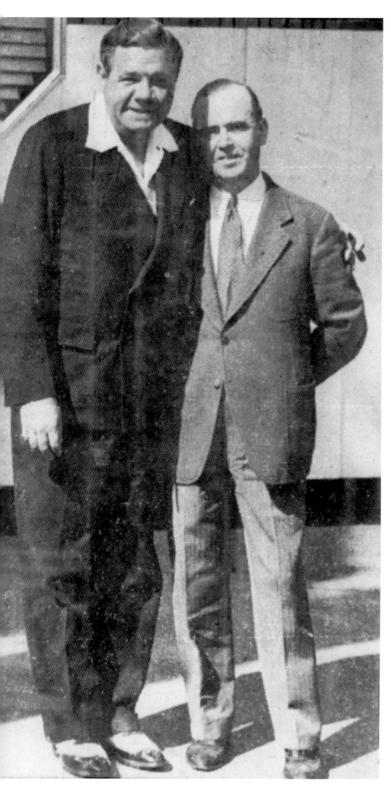

John "Jack" Casey
"Let No Hungry Man Pass This Door" read a sign in the window of Jack Casey's restaurant in the Great Depression years. Casey (1893–1960) and his wife, Della, began the eatery on Railroad Street in Great Barrington about 1920 and moved to Bridge Street three years later. Casey was originally a boxing promoter and an avid baseball player. His eatery also featured the motto, "Where all the sports gather." Both signs told the truth. Casey fed the needy, including hungry boys from the Civilian Conservation Corp. Among the celebrities who enjoyed dining there was baseball legend Babe Ruth (left), who had his photograph taken with Casey in 1941. (Photograph courtesy of Bernard Drew collection.)

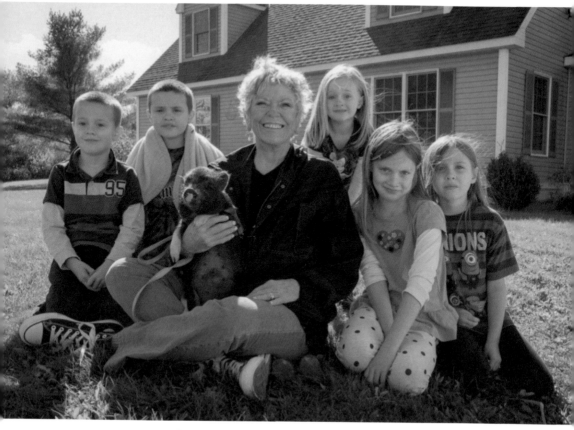

Linda Ellerbee

Linda Ellerbee is an award-winning journalist, author, and network news correspondent. Her career started in radio, and she wrote copy for the Associated Press. She then took a job with CBS television, jumped to NBC, and gained nationwide acclaim reporting for *The Today Show* and cohosting *Weekend* and *NBC News Overnight*. Her work on *Overnight* was recognized with an Alfred I. duPont–Columbia University Award, the broadcast equivalent to the Pulitzer Prize. It was called "possibly the best written and most intelligent news program ever." Ellerbee moved to ABC's *Good Morning America*, also cowriting and coanchoring an Emmy Award–winning primetime historical series, *Our World*.

In the late 1980s, Ellerbee and her husband and business partner, Rolfe Tessem, left network news to start their own company, Lucky Duck Productions. It has produced programs for every major cable network, including Nickelodeon's *Nick News with Linda Ellerbee*.

Ellerbee has written several books, including her well-received autobiography, *And So It Goes*. The title is taken from her sign-off catchphrase, which became her trademark.

Now in her adopted town of Egremont, Ellerbee has gained new fame and appreciation after courageously running down the middle of Route 71, stopping traffic, to rescue a runaway baby pig owned by the children of Jim and Courtney Reynolds. Ellerbee is shown here with Luther the pig, along with the five relieved Reynolds children. They are, from left to right, Liam, Logan, Luna, Lily, and Livia. (Photograph by Rolfe Tessem.)

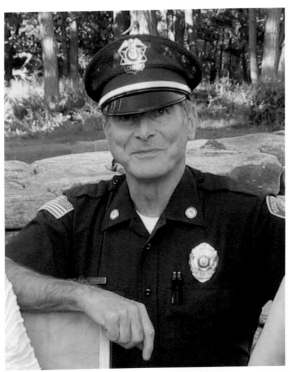

Richard Wilcox
Richard "Rick" Wilcox has family ties to Stockbridge that go back to the earliest settlers. As a youngster, he posed for Norman Rockwell. He returned to Stockbridge after two tours of duty in Vietnam, and he joined the police department in 1971, was appointed chief in 1985, and retired in 2014. Wilcox was ranked as one of the longest-tenured police chiefs in Berkshire County, and also one of the most respected. Helpful, knowledgeable, and blessed with a dry sense of humor, Wilcox is held in high regard by Stockbridge residents and by his police peers. As one resident put it, "every town wishes they had a police chief like Rick Wilcox. He knows when to take charge, he knows when to be diplomatic, and he is smart as hell." (Photograph by Anne Oppermann.)

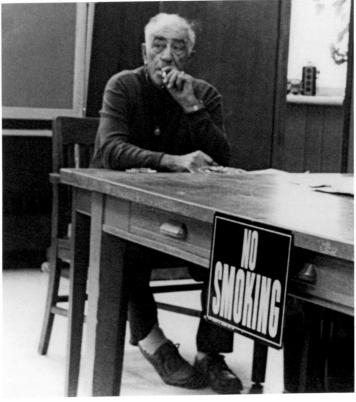

Charlie Castronova
The late 20th century saw two unofficial mayors of Housatonic. One was retired teacher and activist Alice Bubriski. The other was longtime selectman Charlie Castronova, shown here pondering a "No Smoking" sign at town hall. (Photograph courtesy of James Mercer.)

Lucien Aigner

Photojournalist Lucien Aigner (1901–1999) pioneered the use of the 35mm "miniature" candid camera. His dramatic photographs of the 1930s documented a European continent drifting toward war. Aigner's portrait subjects ranged from Winston Churchill to Benito Mussolini to Albert Einstein. He first came to the United States in 1936 and snapped fascinating views of New York City, and Harlem in particular. He immigrated to the United States in 1941 to escape Nazi prosecution. Aigner moved to Great Barrington in 1954 and opened a studio, where he captured the day-to-day life of people and events in the Southern Berkshires. (Photograph by Donald Victor.)

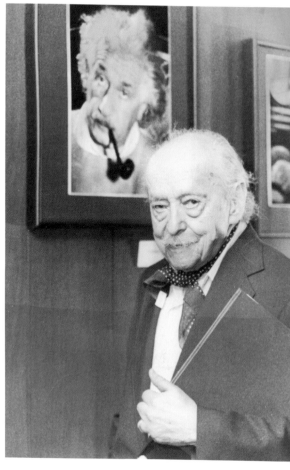

Donald Victor

For 22 years, 2 months, and 1 day, Donald Victor served with the Air Force as a master sergeant, specializing in in-flight communications. He settled in Great Barrington in 1975 and became a prolific photographer of . . . everything! For many years, he was a regular contributor to the *Berkshire Courier* and other newspapers. Over the decades, folks have wondered, "Does he really have film in that camera?" The answer was, "yes"; but not anymore. Victor eventually switched to digital. Keep smiling! (Photograph by Marie Tassone.)

Marie Tassone

A year before her death, Marie Gilman Tassone (1904–1990) was named Great Barrington's "Photographer Laureate." It was a well-deserved honor. Since 1936, she and her husband, Domenic, operated a photography studio here. Tassone's subjects ranged from weddings and celebrations to dog shows and celebrity shoots. After her death, the vast contents of her studio were given to the Great Barrington Historical Society. For the last 20 years, volunteers have been attempting to identify tens of thousands of photographs that she never labeled. (Photograph courtesy of Great Barrington Historical Society.)

Warren Syer

Warren Syer (1923–2007) was the publisher and general manager of *High Fidelity* magazine in Great Barrington. He started with the magazine in 1952. After the periodical was acquired by Billboard Publications, Syer became vice president of consumer publications. He was also publisher of *American Artist* and *Modern Photography* magazines. He founded High Fidelity Cable Television, a multichannel cable system for the towns of Great Barrington, Stockbridge, Lenox, and Lee. (Photograph courtesy of Barbara Syer.)

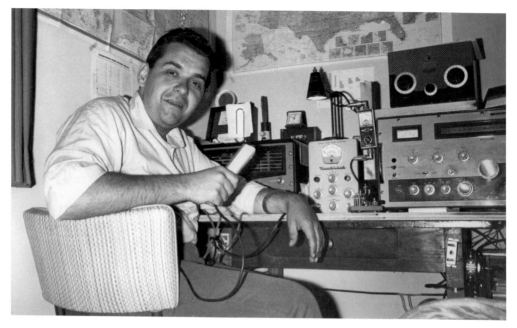

Thomas Jaworski

Thomas Jaworski (1942–2012), better known as "Tom Jay," was the voice of Southern Berkshire news for 43 years at WSBS radio. Teamed up with veteran radio personality Nick Diller, Jaworski was the popular morning show reporter who covered the area's major stories since the mid-1960s. He is perhaps best remembered as the man who kept area residents informed during the deadly tornado of 1995. In the storm's aftermath, Jaworski broadcast live for many hours, serving as a lifeline to a terrified community cut off from the outside world. He is shown here in the 1960s with his "ham" radio. (Photograph by Marie Tassone.)

Gene Shalit and Mary Flynn
Beloved teacher, Stockbridge selectman, and political "grande dame" Mary Flynn (1919–2013) visits with popular *Today Show* film critic Gene Shalit, also a longtime resident of Stockbridge. Flynn was once described as "the heart and soul of Stockbridge." (Photograph courtesy of the Stockbridge Library Museum.)

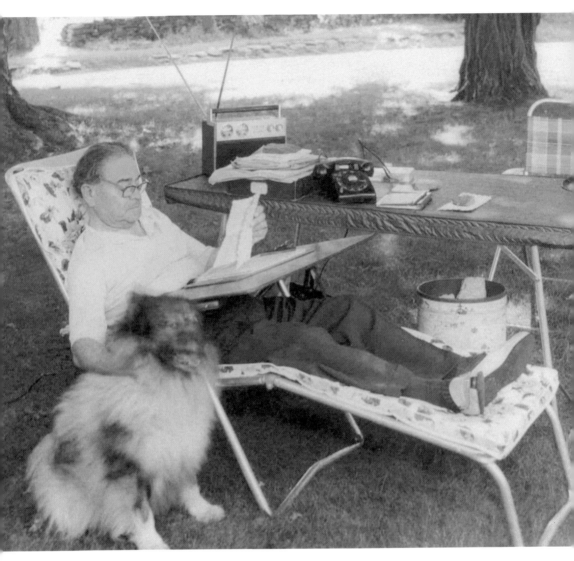

George Sokolsky

George Sokolsky (1893–1962) was one of Sandisfield's most famous residents. His brilliant career as a politically outspoken radio commentator, journalist, and syndicated columnist earned him worldwide respect. A controversial man until his death in 1962, Sokolsky drifted from radical, leftwing activist as a young man to staunch conservative in his later years. His beloved, adopted town of Sandisfield was sometimes the subject of his radio and newspaper commentaries. Prominent public figures and major Hollywood personalities were frequent guests at his home. Pallbearers at his funeral included former president Herbert Hoover, Gen. Douglas MacArthur, and Robert Kennedy. (Photograph courtesy of George Sokolsky Jr. and Ronald Bernard.)

CHAPTER THREE

Entrepreneurs, Explorers, and Inventors

*Man cannot discover new oceans unless he
has the courage to lose sight of the shore.*

—André Gide

From textiles to transformers, cosmetics to curtains, the Southern Berkshires have long been a hotbed of entrepreneurial spirit and scientific advancement. Story Musgrave journeyed from tinkering with tractors as a young boy in Stockbridge to repairing the Hubble Space Telescope. Clever inventors gave us a practical means of transmitting electricity, monitoring the stock market, keeping beverages hot or cold, and taking better photographs.

Each person in this chapter represents many additional individuals who have also explored new frontiers, secured quality employment for others, or provided an improved way of life for this town, state, country, and planet. For example, 19th-century electrical innovator Franklin Pope has a counterpart in present-day Jeb Rong of Mount Washington, who harnesses electromagnetic energy for underground exploration and radio frequency heating to remove ground contaminants. Of course, another Southern Berkshire resident genius is Douglas Trumbull, the special-effects wizard, film director, inventor, and theme-park-ride innovator.

The old photograph of rake-meister Marshall Stedman of Tyringham also honors the entrepreneurial efforts of modern-day brewmeister Chris Weld of Sheffield, who is creating flavorful new spirits pleasing to the palate. And speaking of good spirits, the Domaney family of Great Barrington has served South Berkshire with exceptional products and customer service since 1973. Equally respected is the Tracy family's Gorham & Norton's store—the oldest business in Great Barrington.

Former axle-maker David Dalzell of Egremont, described in this chapter, has a contemporary match in the Chamberlain Group. The Great Barrington firm, headed by Lisa and Eric Chamberlain, designs and manufactures anatomically accurate medical models and body parts. Dalzell's work also calls to mind the energetic Cowan family that has been operating the ever-popular Sheffield Pottery since 1946. And down the road a few miles, Dale and Phyllis Webb's Magic Fluke company has created a local phenomenon with their handcrafted ukuleles. We are blessed to live among so many brilliant innovators and visionaries.

Story Musgrave

With a career spanning the NASA space program of the 1960s through the 1990s, Story Musgrave is the only astronaut to have flown on all five Space Shuttles. He is also a surgeon, mechanic, poet, philosopher, and motivational speaker.

Born in 1935, during the Great Depression, and raised on a dairy farm in Stockbridge (now the home of the Norman Rockwell Museum), Musgrave was operating and repairing tractors and farm machinery by the age of 10. As a child living in a home environment of alcohol and abuse, Musgrave escaped whenever he could into the nearby woods and fields, developing a lifelong love of nature.

A complete review of Musgrave's accomplishments would fill the rest of this book. He began flying at age 16 and has accumulated 18,000 hours piloting over 160 aircraft. He entered the US Marine Corps in 1953, served as an aviation electrician and instrument technician, and was an aircraft crew chief in Korea, Japan, and Hawaii. Musgrave has graduate degrees in math, computers, chemistry, medicine, physiology, literature, and psychology.

Dr. Musgrave worked in aerospace medicine and physiology, as well as in cardiovascular and exercise physiology. He was also a surgeon and professor of physiology and biophysics. He performed the first shuttle spacewalk on *Challenger*'s first flight, was the pilot on an astronomy mission, conducted two classified missions, and was the lead spacewalker on the Hubble Space Telescope repair mission. He continues to lead a busy life as a public speaker and design consultant. (Photograph by Dana Ranga.)

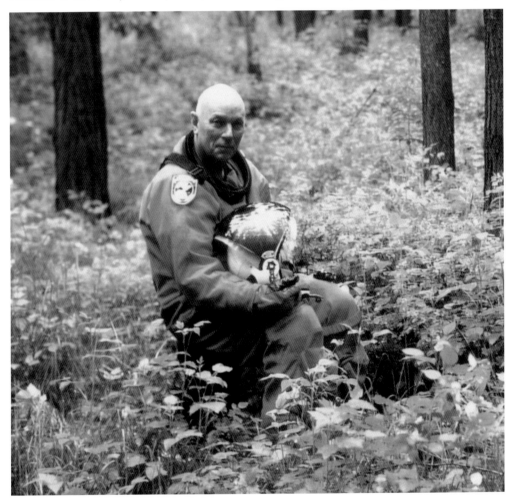

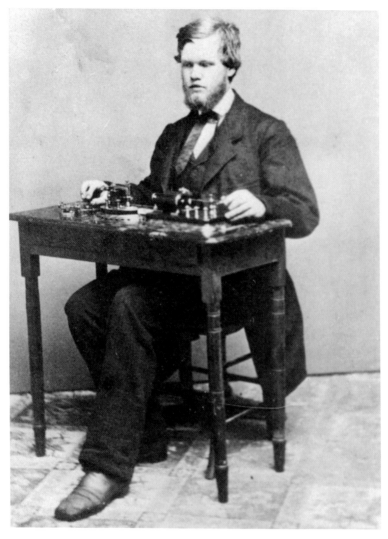

Franklin L. Pope

Franklin Pope (1840–1895) helped invent the stock market ticker-tape machine and developed advancements in telegraphic devices. Born and raised in Great Barrington, the versatile Pope was also an author, artist, cartographer, engineer, electrician, historian, and patent expert.

Pope began his career as a local telegrapher, moved up to management, worked as an artist for *Scientific American*, and later explored the Pacific Northwest wilderness with his brother Ralph, seeking to establish a telegraph line along the Bering Strait between North America and Russia. He then partnered with Thomas Edison to develop what became the stock market ticker-tape machine. Pope and Edison also patented a clever railroad signal system. Pope was a technical journal editor who authored several books and numerous articles. He also worked in Washington, DC, as a renowned patent expert. In the Southern Berkshires, he supervised the construction of a hydroelectric plant in Glendale, along with the installation of alternating current transmission lines. He remodeled his 1766 family home on South Main Street, which he renamed Wainwright Hall, after his maternal ancestors. Today, it is a popular bed-and-breakfast. Pope's death at the age of 55 was, ironically, the result of an accidental electrocution in his basement workshop. (Photograph courtesy of National Park Service, Thomas Edison National Historical Park.)

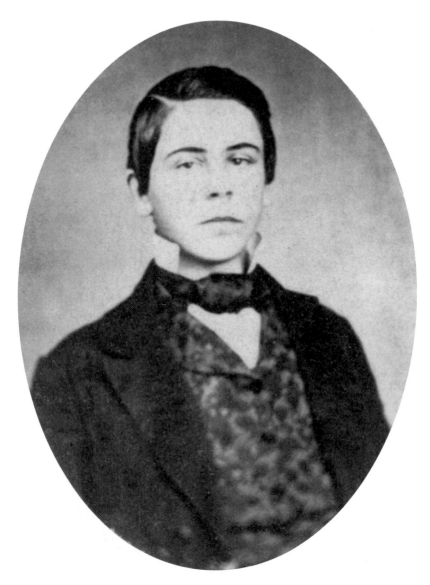

Marcus Rogers

Born in Mill River, Marcus Rogers (1835–1926) remained a resident of that New Marlborough village for much of his life. By age 14, the clever lad had crafted a printing device from his mother's cheese press and began publishing a local paper. Much later, he became an enterprising editor/publisher of the *Berkshire Courier*. Rogers also owned the *Berkshire Eagle* for a time. Until Rogers took over the *Courier*, the thin newspaper carried very little local news. Often credited with creating the concept of "country correspondent," Rogers boosted readership and subscriptions dramatically in outlying towns with his village-by-village reports. These folksy columns evolved into alliterative titles such as "Glendale Gleanings," "Housatonic Happenings," "Monterey Matters," "North Egremont Notes," "Sandisfield Siftings," "Sheffield Sparks," and "Stockbridge Saunterings." An amateur astronomer and poet, Rogers was as clever in his business dealings and technical expertise as he was with newsgathering. In 1878, he invented a newspaper-folding machine, which made him a small fortune. He became a worldwide traveler, but always returned to Mill River, where he remained a generous philanthropist until his passing at age 90. This photograph was taken when he was 17 years old. (Photograph courtesy of BerkshireArchive.com.)

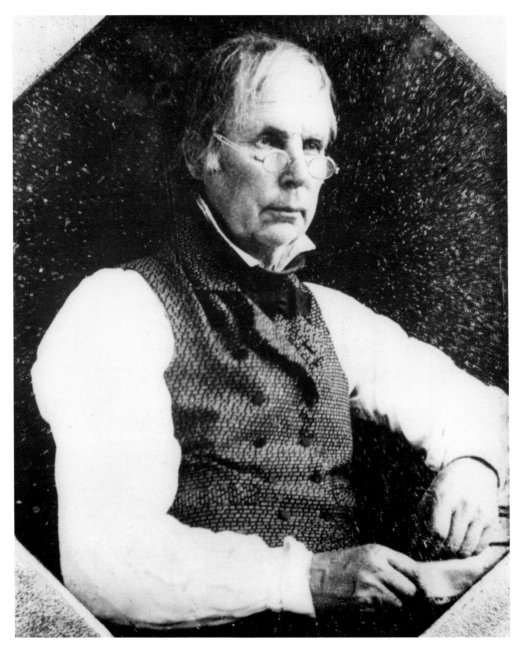

Anson Clark

Photography arrived in Berkshire around 1840, when tinkerer Anson Clark (1788–1847) and his son Edwin began making daguerreotypes in West Stockbridge. The senior Clark worked first as a marble cutter, but he displayed a genius for mechanical innovations and inventions, including equipment for cutting and polishing marble. He then branched out, crafting and selling musical instruments. By 1841, he and his son opened a photography studio in West Stockbridge, and later in Great Barrington. Unhappy with the quality of lens made in New York City, they ground their own. The duo then manufactured and sold cameras, training numerous students in the fledging art of photography. (Photograph courtesy of Stockbridge Library Association Museum.)

William Hall Walker

William Walker (1846–1917) was associated with Kodak founder George Eastman in the early development of his revolutionary, easy-to-use camera. Walker later organized the European branch of Eastman Kodak, where he remained in charge for 20 years. In 1908, he purchased the Brookside estate in Great Barrington, formerly owned by inventor William Stanley. Here, Walker held lavish parties where guests marveled at his elaborate Italianate gardens. The property is now home to the Eisner Camp for Living Judaism. Walker was a philanthropist who donated generously to the Thursday Morning Club, Fairview Hospital, and the Visiting Nurse Association. (Photograph courtesy of BerkshireArchive.com.)

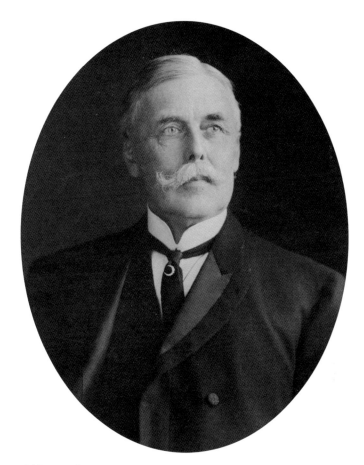

B.D. Rising and Henry Cone

Henry Cone (1836–1896) was the sometimes benevolent, often grumpy owner of the Owen Paper Company, a predecessor to Rising Paper in Housatonic. A visionary and risk-taker, his life was one of triumph and tragedy. Cone was first a bookkeeper with the company. He later married the widow of Edward Owen, the company founder. Cone had big plans for the paper mill that were, at first, successful. He moved the old wooden mill buildings away from the Housatonic River (the present-day Beehive Condominiums is one of the original structures), and he built a bigger dam across the river, creating a large millpond for power. He established the Cone Library and Reading Room in Housatonic, the biggest library in Great Barrington at the time. He also helped promote the fledging Housatonic Water Works, which would provide fire protection and safe drinking water to the village. In 1876, his fine paper won first prize at the Philadelphia Centennial World's Fair.

Cone began construction of a large Victorian brick factory downriver from the old mill, but he ran out of money before he could complete it and install machinery. He had invested a fortune attempting to build a railroad from Columbia County, New York, to Springfield, Massachusetts, but failed in this venture when competing capitalists with much deeper pockets built another railroad. His company struggled on, but it ultimately failed in 1892. Cone died almost penniless.

Cone's Centennial Mill, so-called because it was built in 1876, the nation's centennial, was left abandoned and incomplete. It stood empty for years before it was finally rescued by papermaker Bradley D. Rising (shown here) in 1899. He, along with factory superintendent Robert Harper, installed state-of-the-art equipment, and the company became a great success. Although Rising died in 1903, the company continued under his name with several owners, including Strathmore Paper and Fox River Paper. The mill is now owned by Hazen Paper Company. (Photograph courtesy of Great Barrington Historical Society.)

Jane and Jack Fitzpatrick
An entire book could be devoted to the extraordinary lives of Jane Fitzpatrick (1923–2013) and her husband, former state senator John "Jack" Fitzpatrick (1923–2011). They were considered by many to be the "First Family of the Berkshires." The couple established Country Curtains in 1956, growing it into an innovative manufacturing, mail-order, and retail operation—and making the world a more beautiful place, one window at a time. The Fitzpatricks purchased the shuttered Red Lion Inn in 1968, restored it, and created an iconic Stockbridge destination for visitors from around the world. Nearby Blantyre Castle was acquired in 1980 and continues to provide the best in Berkshire hospitality. The list of accomplishments goes on and on. Providing employment for thousands over the years, the Fitzpatricks were also generous philanthropists, supporting numerous cultural organizations throughout the Berkshires. Daughters Nancy Fitzpatrick (third from left) and Ann Fitzpatrick Brown (fourth from left) carry on the tradition today. This photograph was featured on a 1978 senate campaign postcard. (Postcard courtesy of BerkshireArchive.com.)

Anna Bingham

Anna Dix Bingham (1745–1829) founded what is now the Red Lion Inn in 1778. According to historian Lion Miles, she was the first businesswoman of Berkshire County. Besieged with debt, she resisted domineering bill collectors who would, she wrote, "Divour Widows Houses." By 1797, she was entangled in a business dispute with a man from Hudson, New York, and bravely took the case to the US Supreme Court, the first example of a woman standing before that court. She is recognized as such in *The Documentary History of the Supreme Court*. No portraits exist of Bingham, but her inn eventually achieved fame under the guidance of her 20th-century protégé, Jane Fitzpatrick. Shown here is one of the earliest known photographs of the inn, taken in 1866. It shows the original building along with an 1846 addition (left). (Photograph courtesy of the Stockbridge Library Museum.)

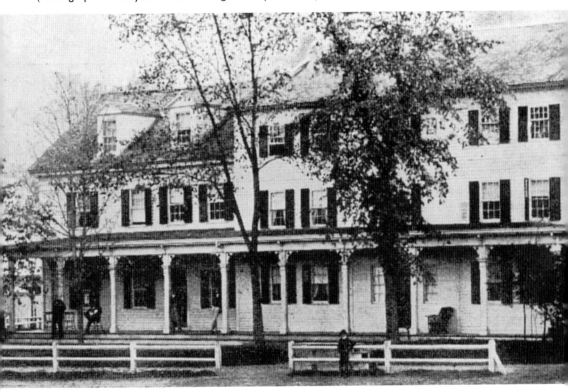

Jane Iredale

After moving to the United States from Great Britain, cosmetics pioneer Jane Iredale began her career as a casting director in New York City. She worked alongside actors whose success depended on a clear complexion, but she was witness to how skin disorders and sensitivities to harsh theatrical makeup not only threatened careers, but also destroyed self-confidence.

One night, Iredale woke up with an epiphany. She decided to open her own business producing superior cosmetics that would be healthy and nourishing for the skin. Jane's passion for health and wellness was her motivation to create products with natural ingredients that would help the health of the skin. She started the company out of her home in Austerlitz, New York, and then moved to Great Barrington, where her business has flourished. Her brand, jane iredale: The Skin Care Makeup, now sells products in more than 40 countries, and it continues to grow rapidly, providing good jobs for many local residents. (Photograph courtesy of Jane Iredale.)

Marshall Stedman

Marshall Stedman (1859–1935) ran a successful rake manufactory in Tyringham for many years. He was a smart businessman who combined quality products with clever self-promotion. He generated much publicity by giving rakes to several US presidents, including Theodore Roosevelt and Calvin Coolidge. In the below photograph, President Coolidge (center) and his father, John Calvin Coolidge Sr. (right), along with carmaker Henry Ford, examine two of Stedman's rakes. (Photograph of Stedman courtesy of Bernard Drew collection; photograph of presidential rakes courtesy of BerkshireArchive.com.)

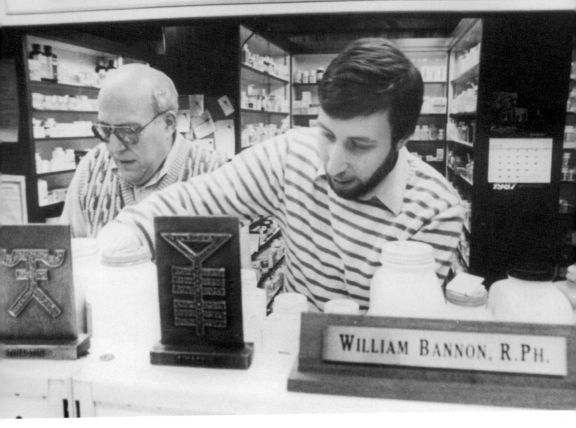

Drugstore Giants (ABOVE AND OPPOSITE PAGE)
Melvin Katsh (1916–2000) and Bill Bannon (1919–2004) owned pharmacies featuring their first names. Bernard Green (1922–2011) operated Harper's Drugstore. Katsh (opposite page, above image), Bannon (above, with son Stephen), and Green (opposite page, below image, with grandson Joshua Jones) were the big-three drugstore giants in the second half of the 20th century. When Stephen Bannon took over Bill's Pharmacy, it was the last independent drugstore in South Berkshire. A partial list of other memorable Great Barrington pharmacists from bygone days includes John Harper, Ralph Yurkee, and Joseph Mogan. (Photographs by Donald Victor.)

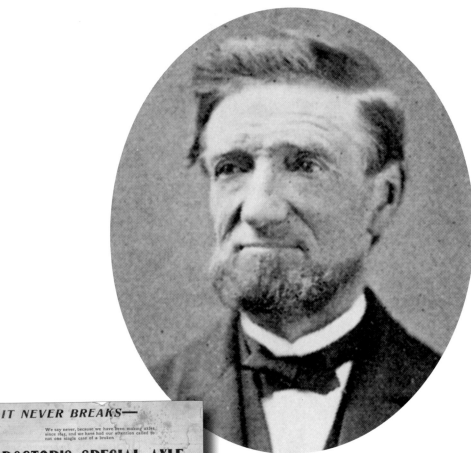

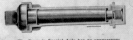
David Dalzell and Family

Egremont was once a major hub of axle manufacturing. And the kingpin of the operation was David Dalzell (1811–1879), followed by his sons David Jr. and William. Born in Scotland, David Dalzell came to the United States with his mother at a young age. After apprenticing with carriage builders in Albany, he purchased an old carriage works in South Egremont. Before long, he patented improved axle designs and began manufacturing them. His award-winning exhibit at the Philadelphia Centennial World's Fair in 1876 gained significant business for the company, and Dalzell produced axles and axle boxes for top carriage companies, including Studebaker. The company kept up with the latest technology, and a trolley line was built to South Egremont, in part to bring workers to the factories. But the Dalzell team was blindsided by the arrival of the automobile. Although the company began making a few parts for cars, it was too little, too late, and the firm closed its doors in 1909. (Dalzell photograph courtesy of Bernard Drew collection; Dalzell advertisement courtesy of BerkshireArchive.com.)

Osa Johnson

Many notables have resided in Otis over the years, including William and Helen Laidlaw, Bill Hall, Charles Humason, and Clifford Clark. But it was a frequent Otis summer visitor that captured everyone's imagination. Her name was Osa Johnson (1894–1953). In the first half of the 20th century, she and her husband, Martin, were world-renowned explorers and filmmakers, studying wildlife and native peoples in Africa and the South Pacific Islands. Their hugely popular films included *Jungle Adventurers, Headhunters of the South Seas, Trailing Wild African Animals, Congorilla*, and *Osa's Four Years in Paradise*. Known for their zebra-striped amphibian plane, they were the first pilots to film Mount Kilimanjaro from the air. They also made the first sound movie shown during an airline flight. In 1935, they even appeared on Wheaties cereal boxes. Martin Johnson died in a 1937 plane crash, which also seriously injured Osa. But she recovered and wrote the bestselling book of 1940, *I Married Adventure* (inset). She later hosted television's first wildlife series, *The Big Game Hunt*. The Johnsons' film footage and photographs have been used in several Disney movies and at its Animal Kingdom theme park. The Martin + Osa clothing line was launched by American Eagle Outfitters in 2006. (Photograph of Osa Johnson courtesy of George Eastman House Collection; inset courtesy of BerkshireArchive.com.)

Karl Lipsky
Karl Lipsky (1914–2009) was owner of the Jenifer House, a popular retail complex and Americana mail-order catalog. Initially based in New Marlborough, the company later expanded at an old farm along Stockbridge Road in Great Barrington during the 1950s. Lipsky is shown here in 1999 with his grandchildren Jenifer and Henry Fuore. (Photograph by Donald Victor.)

Mr. and Mrs. *Shopper's Guide*
John (pictured) and Eunice Raifstanger established the *Shopper's Guide* in 1968 as a remarkably effective way to connect buyers and sellers in the Southern Berkshires. Today, residents and visitors continue to look through the paper to find out what is going on. Readers and advertisers appreciate the free weekly, which fosters the local economy and promotes community. (Photograph courtesy of the *Shopper's Guide*.)

Fred Pearson

Fred Pearson (1861–1915) was a professor of chemistry and mathematics who became a distinguished electrical engineer. Working with several major corporations on railroad, trolley, mining, irrigation, and lumbering projects, he amassed a fortune by age 30. In the early 1900s, he acquired property along Division Street in Great Barrington and built a hilltop mansion overlooking Long Pond. Pearson eventually accumulated 13,000 acres of land in Great Barrington, Monterey, Alford, and Austerlitz. He stocked his acreage with exotic game from around the world. He employed 75 workers to take care of his horses, sheep, poultry, orchards, extensive gardens, and vast lawns. In the spring of 1915, Pearson and his wife boarded the ill-fated luxury liner *Lusitania* for a trip to Spain. German torpedoes sunk the ship, and the Pearsons perished. (Photograph courtesy of Housatonic Water Works Archives.)

Edward Harwood

Col. Edward Harwood (1900–1980) founded the American Institute for Economic Research (AIER) in 1933. AIER is one of the oldest nonprofit, scientific research organizations in the United States specializing in economics. It is also the parent of a for-profit subsidiary, American Investment Services. During World War II, Harwood advanced to the rank of colonel and earned the Legion of Merit and Bronze Star medals. After leaving the service, he relocated AIER to the Fred Pearson estate in 1946. Edward Harwood, shown here with his wife, Helen, devoted the rest of his life to his work in economics, investing, and scientific methodology. (Photograph courtesy of AIER.)

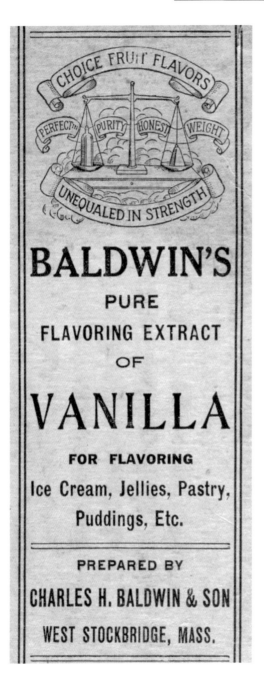

CHOICE FRUIT FLAVORS

PERFECT PURITY HONEST WEIGHT

UNEQUALED IN STRENGTH

BALDWIN'S

PURE

FLAVORING EXTRACT

OF

VANILLA

FOR FLAVORING

Ice Cream, Jellies, Pastry,

Puddings, Etc.

PREPARED BY

CHARLES H. BALDWIN & SON

WEST STOCKBRIDGE, MASS.

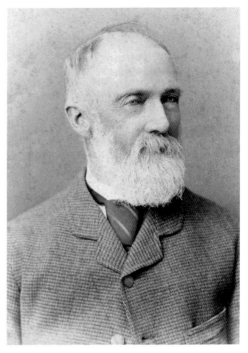

Baldwin and Moffatt Families

The Baldwin and related Moffatt families have played a significant role in the history of West Stockbridge since the 1800s. Henry Baldwin (above) was the founder of the medicinal and baking extract firm named after his son Charles, and then operated by grandsons Arthur and Earl. Arthur and his descendants later focused on the still-thriving hardware business on Center Street. Local residents greatly appreciate the superb customer service, quality, and extensive stock offered by A.W. Baldwin's Hardware. Earl's descendants have continued with the ever-popular Charles H. Baldwin & Sons store on the opposite side of the street, which offers their legendary vanilla extract, as well as other pure extracts, flavorings, syrups, unique gifts, and gadgets. (Photographs courtesy of West Stockbridge Historical Society.)

Hugh Smiley

Hugh Smiley (1886–1973) first set foot in Egremont in the mid-1920s. He changed the town dramatically. Smiley came from New York State where his elders owned the famous Mohonk Mountain House in New Paltz. An avid gun collector, Smiley amassed one of the largest privately owned collections in the world. But he also had an interest in farming. In Egremont, he established a state-of-the-art dairy farm, but he then expanded his horizons, turning his giant barn into Jug End Barn resort. Smiley envisioned Egremont as a village-wide resort; before long, he and fellow investors owned thousands of acres in town, as well as inns, taverns, tearooms, even the general store. Log cabins and cottages were built and sold on land held in common by the shareholders of Olde Egremont Association. The group even published its own newspaper. Business was good for a time, and Smiley provided much-needed employment. According to one resident, before Smiley arrived, "the village was poor, the houses unpainted. Egremont is beautiful today as a result of his fixing it up." But the deepening Great Depression was Smiley's downfall. When money ran out, Smiley was forced to sell off his holdings. His great vacation experiment was over. (Photographs courtesy of Nancy-Fay Hecker.)

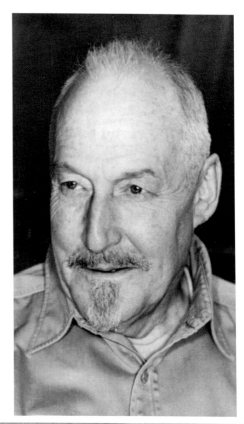

JUG END BARN, SOUTH EGREMONT, MASS.

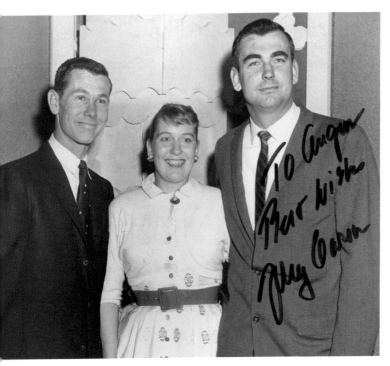

Mimi and Angus MacDonald During the 1950s and 1960s, Jug End Barn resort in Egremont achieved it greatest glory with owners Angus and Mimi MacDonald. Both were held in high regard by guests and locals, and their popular vacation retreat provided good jobs for hundreds of people. The MacDonalds are shown here with Johnny Carson (left), as Mimi appeared on Carson's 1950s television game show, *Who Do You Trust?* (Photograph courtesy of Nancy-Fay Hecker.)

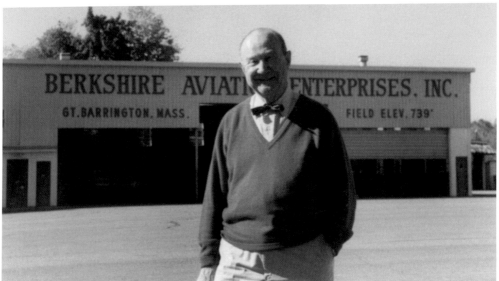

Walter "Walt" Koladza
Walt Koladza (1918–2004) operated an airport longer than anyone else in Massachusetts—more than half a century. In 1940, Koladza moved to the Berkshires to be an instructor in the war-training flight program at Berkshire School in Sheffield. After supervising countless training flights before and during World War II at the Great Barrington Airport, he bought the 100-acre facility in 1944. He also founded Berkshire Aviation Enterprises. With his partner, Rocco Traficante, he offered flight instruction, charter service, airplane repair, scenic rides, and aerial photography. The airport is now named after Koladza. (Photograph courtesy of Great Barrington Historical Society.)

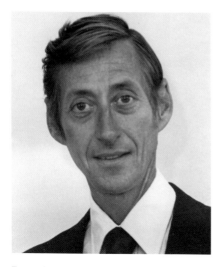

Donald "Don" Ward

Don Ward of Great Barrington started Ward's Nursery and Garden Center in 1957. Don's sons and family carry on the tradition today with the help of a dedicated and knowledgeable workforce. The Ward family was chosen at the 2010 Business Persons of the Year by the Southern Berkshire Chamber of Commerce. (Photograph courtesy of James Mercer.)

Steven Carlotta and Anthony Carlotto

Although cousins Steve Carlotta (left) and Tony Carlotto are not camera-shy, they prefer to stay behind the lens at the Snap Shop, the oldest business on Railroad Street in Great Barrington. In the ever-changing world of photography, they manage to stay one step ahead of the curve. Another key to their success: the best products, great advice, and superb customer service. (Photograph courtesy of Great Barrington 250th Anniversary book.)

Caligari Family

For more than 100 years in the Southern Berkshires, the name Caligari has stood for top-notch redecorating, hardware, cleaning supplies, and interior design. The initial company was founded by painting contractor Gene Caligari. It was greatly expanded by his son William, shown here in 1990. His children continue to run several different family-named businesses today. (Photograph by Donald Victor.)

Otis Egg Men
Following his service in World War II, Maxwell Pyenson (1916–2010) joined his father, David, in running the Otis Poultry Farm. Max is shown in the doorway inset of this photograph. He and, later, his sons Andrew and Steven, took over the operation famous for its whimsical roadside signs and superb chicken and turkey pies. (Photograph composite courtesy of BerkshireArchive.com.)

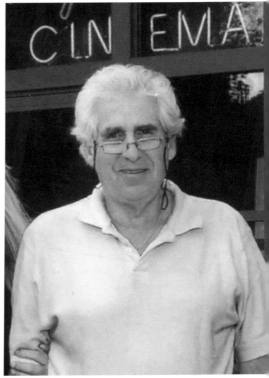

Richard Stanley
Richard Stanley had a vision. He and architect Joe Wasserman set out to revitalize a portion of downtown Great Barrington that had seen better days. After struggle and debate, their dream was accomplished with the renovation of the Barrington House block and the opening of the Triplex Theater. Looking back, it seems clear that Stanley's effort was a major catalyst for the renaissance of downtown. (Photograph courtesy of Great Barrington Historical Society.)

CHAPTER FOUR

Hands to Work, Hearts to God

*Do your work as though you had a thousand years to live
and as if you were to die tomorrow.
Put your hands to work, and your heart to God.*

—Mother Ann Lee

This chapter includes individuals from diverse backgrounds, not commonly grouped together. That's what happens when an old Shaker expression is used as a chapter title. Perhaps there is a common thread between farmers and missionaries, healers and theologians, even a beloved doll.

Certainly, there is something spiritual about working the land. Just ask Dan Tawczynski of Taft Farms in Housatonic. And many of us benefit from the deep-rooted and diverse crop of spiritual individuals and organizations in the Southern Berkshires. From the enlightened psychological guidance of Erik Erikson in Stockbridge to the lifelong efforts of Agnes Gould in Monterey, this area has been a healing home for thousands. Of course, Berkshire-based secular organizations such as local food pantries and community centers also provide heartwarming support and nourishment for residents.

Even a very partial list of doctors who have capably served the Southern Berkshires in years gone by could fill a book: William Whiting, Samuel Barstow, Samuel Camp, Clarkson Collins, Louisa Millard, Mortimer Cavanaugh, Theodore Giddings, Orville Lane, Edward Wyman, Marion MacCormack, Donald Campbell, Thomas Gilligan, Peter Albano, Albert Chesanow, Harvey Lucksinger, Wellington Jones, Arthur Cassel, John Beebe, Thomas Whitfield, Henry Erbe, Charles McBurney, Morgan Vigneron, Waldo Edelman, and Dennis Tresp, to name just a few. The same holds true for spiritual leaders. In fact, each person in this chapter serves as a symbol of the multitudes that worked the land, or brought physical and spiritual healing to our community. For example, when you read about the late Rabbi Jacob Axelrod, think also of his contemporary, Rabbi Deborah Zecher. When you view the photograph of Father Anthony Jutt of Housatonic, remember Reverend Esther Dozier of the Clinton AME Church and Pierce Middleton of St. James Episcopal Church. Or when you see the photograph of the late James Chase of Egremont, don't forget Reverend Jill Graham of Sheffield, or Reverend Joseph Forte of the Macedonia Baptist Church. The list goes on.

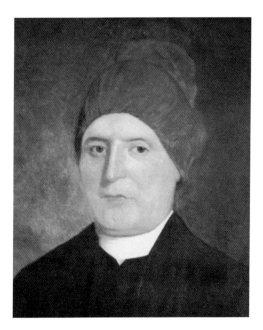 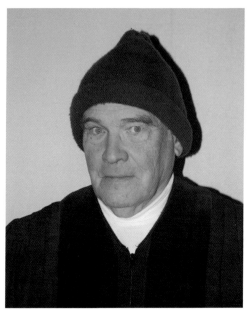

Samuel Hopkins and Charles Van Ausdall

Great Barrington's first Congregational minister became one of America's great theologians. But he gained his fame only after relocating to Newport, Rhode Island.

Rev. Samuel Hopkins's theology might be described as "strenuous." For instance, he taught that the love of God must be so complete, so unselfish, that one should be gladly willing to suffer eternal damnation for God's sake. In the latter years of the 18th century, Hopkins's style of Congregationalism was widely influential across New England. It even generated its own name: Hopkinsianism.

Perhaps Hopkins's experience in Sheffield's North Parish (later incorporated as Great Barrington) from 1743 to 1769 helped form his personal readiness to accept damnation for God's sake. He may have felt he was apprenticing for that role in Berkshire, as Rev. Hopkins (1721–1803) had considerable difficulties as minister in the town. He found the unruly residents of this distant outpost more interested in gambling and horse racing than saving their own souls. And some locals did not hesitate to challenge his strict religious views—after they were coerced into attending service. The turbulent relationship escalated when townsfolk refused to pay Hopkins his allotted salary. Hopkins (pictured above, left) was finally removed from his post after a stormy selectmen's meeting.

There were joyful aspects to his 26 years in Great Barrington, especially the pleasure he found with family and friends. Hopkins's mentor, Jonathan Edwards, had been removed from his parish in Northampton for his own demanding religious enthusiasm. He joined Hopkins in South Berkshire, Edwards serving as pastor to Stockbridge. Their reunion must have been of solace to both. Hopkins's diaries describe their time together, including riding horseback and preaching in each other's parish. They rode together to Litchfield County, Connecticut, to join their friend and pastor Joseph Bellamy, an important theologian in his own right.

No doubt, Hopkins was a devoted and deeply committed pastor to his parishioners, despite his stern religious beliefs. And it is important to note that he was the first New England minister to speak out against slavery.

Only one other Congregational Church minister in Great Barrington has achieved the same longevity in the pulpit—Charles Van Ausdall, the present pastor. He was called to Great Barrington in 1986, and he passed Sam Hopkins's record of 26 years in 2012. Contrary to Hopkins, however, Van Ausdall (above, right) is well regarded in town, and he is reportedly paid on time! When wearing a red wool ski hat, "Pastor Van" does bear a resemblance to his predecessor. (Photographs courtesy of the author.)

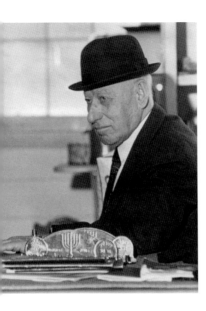

Rabbi Jacob Axelrod
Rabbi Jacob Axelrod (d. 1986) emigrated from Poland to Great Barrington in 1926 and became the first resident rabbi for the Love of Peace Synagogue (later Ahavath Sholom) on North Street. He also operated a kosher deli in a small building behind his house. Rabbi Axelrod devoted himself to his Orthodox congregation and his community for 60 years. His son, Dr. David Axelrod, went on to become the New York State health commissioner. (Photograph by Donald Victor.)

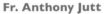

Fr. Anthony Jutt
Over the past 50 years, Fr. Anthony Jutt holds the record for the longest stay of a parish priest in Housatonic. He served as the spiritual leader of Corpus Christi Roman Catholic Church from 1972 until his retirement in 2006. In 1992, he also took over responsibilities at All Saints Church. His devotion to both parishes will long be remembered. (Photograph courtesy of James Mercer.)

Anson Phelps Stokes
Anson Phelps Stokes (1874–1958) was an educator, clergyman, author, philanthropist, and civil rights activist from Stockbridge. His father was a New York City banker who built the Shadowbrook mansion, later the home of steel magnate Andrew Carnegie. The building then became a Jesuit seminary, and it is currently the site of Kripalu Center for Yoga and Health. Anson Phelps served as an Episcopal priest and second in command at Yale University. He was also involved in numerous civic causes and guided the Phelps Stokes Fund toward improving the lives of African Americans. His descendants and relatives still live in the Southern Berkshires. (Photograph courtesy of Thomas Stokes.)

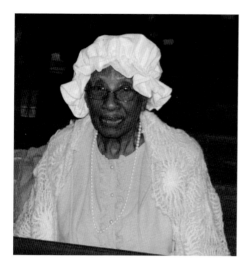

Mae Brown

Beloved Mae Brown of Housatonic turned 99 years old as this book was being written. In this photograph, she is dressed in Colonial costume for Great Barrington's 250th anniversary celebration in 2011. For decades, Brown was in charge of the home economics department and food service program at Lenox High School. As a child, she was taught that "if they close the door on you, go in the window." This quote by Brown was used as the title of a book by author Bernard Drew that touches on the history of the African American community in the Southern Berkshires. "I thank God every day," said Brown, who is active in the First Congregational Church. "I was never taught prejudice. I never felt envy toward anybody." (Photograph by the author.)

Agnes Gould

In 1913, Agnes Goodyear Gould (1868–1958) and her husband, Will, founded Gould Farm, a residential rehabilitation community in Monterey for people with mental illness. After her husband passed away in 1925, Gould assumed the leadership of the farm. Today, Gould Farm is a highly respected psychiatric recuperation center offering care, work, rest, and counseling. (Photograph by Lucien Aigner; courtesy of Gould Farm.)

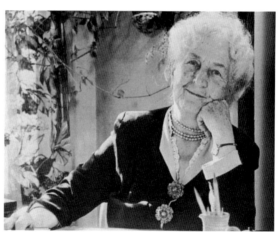

Mortimer Cavanaugh, Father and Son

Dr. Mortimer Cavanaugh (d. 1945) was a highly respected physician in Great Barrington and chief of medical staff at Fairview Hospital. Dr. Cavanaugh (left) fixed numerous broken bones, and his son and namesake went on to fix hundreds of broken pipes as the founder of M.T. Cavanaugh Plumbing & Heating. The younger Cavanaugh (right) also served as the longtime Great Barrington fire chief from 1955 until 1993. (Dr. Cavanaugh photograph courtesy of BerkshireArchive.com; Fire Chief Cavanaugh portrait by Frank Packlick.)

Daniel Tawczynski
Daniel Tawczynski, a.k.a. Danny Taft, has always had a green thumb. For over 50 years, he has nurtured the ever-popular Taft Farms market at the intersection of Route 183 and Division Streets in Housatonic. He got into the business as a teenager when he and his half-brother Stanley Piatkowski built and opened a fruit and vegetable stand. In 1962, Tawczynski quit his job as an English teacher so he could focus full-time on the farm. Today, four generations of "Tafts" keep things growing. (Photograph by Tom Casey; courtesy of the *Berkshire Record*.)

Rev. James Chase
In many communities, ministers come and go. But the beloved Rev. James Chase (1917–1992) of Egremont and Mount Washington served this area for most of his adult life. In addition to his ministry in North and South Egremont, he was a founding member of the popular local radio program *Inspiration Time* and served on the board of trustees at Fairview Hospital. The diagnostic imaging center at the hospital was named in his honor in 1991. Chase was also a founder of HospiceCare in the Berkshires and served as a volunteer in the South Egremont Fire Department. He received many honors and awards over the years, including Citizen of the Year by the Kiwanis Club. Seen here in the late 1950s, Chase (third from left) and church members have a "holy cow!" moment as they greet a Baptist bovine. (Photograph by Marie Tassone.)

Fairview Hospital Staff

For 100 years, Fairview Hospital has been at the center of medical services for the Southern Berkshires. And two of Fairview's physicians have been at the core of such services for more than a third of that century. Doctors Ray Sabatelli (left) and Brian Burke (right), shown here in photographs taken more than 25 years apart, are still at it.

"Doc Sab" moved Fairview's emergency services into the modern world when he arrived as emergency director in 1976. He has maintained that leadership position ever since, including his instrumental role encouraging Southern Berkshire Volunteer Ambulance Service to initiate the area's first paramedic service. Dr. Burke joined Fairview's medical staff in 1981. He has been annually elected Fairview's chief of staff for over 20 years, and for the last 10 years has also been Fairview's medical director. In addition, Dr. Burke was cofounder of the Community Health Program. In 2010, he was recognized as the Rural New England Clinician of the Year. Leading the Fairview team are Eugene "Gene" Dellea, president of Fairview Hospital, and Tony Rinaldi, executive vice president. They set the example for all of the dedicated local legends found at Fairview—doctors, nurses, technicians, support staff, and administrators. (*Then* photograph above by Dr. Harold Sherman; *now* photograph below by the author.)

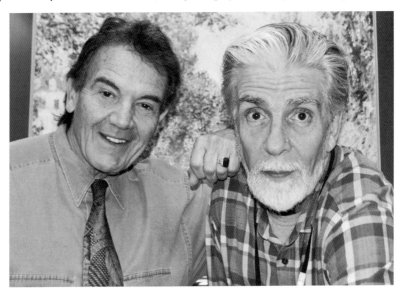

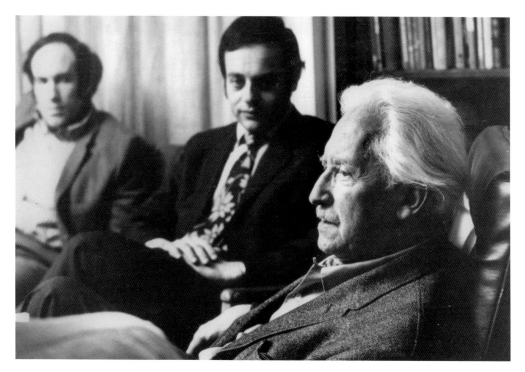

Eric Erikson

Pulitzer Prize–winning author Erik Erikson (1902–1994) was a gifted developmental psychologist and psychoanalyst, perhaps best known for coining the phrase "identity crisis." After a challenging childhood in Germany, Erikson trained in Vienna with Anna Freud. In 1933, he immigrated to the United States, where he practiced child psychoanalysis. Erikson's influence helped broaden and expand psychoanalytic theory and contributed to the understanding of children and of "personality" as it develops during adolescence and adulthood. During the 1950s, Erikson worked and taught at the Austen Riggs Center in Stockbridge, a prominent psychiatric treatment center, where he helped emotionally troubled young people. (Photograph courtesy of Austen Riggs Center.)

Hitty

Hitty is an antique doll with a bit of a cult following. She has a fan club and is honored, studied, and enjoyed at annual conventions. Hitty hit the big-time in 1929, when she appeared in *Hitty, Her First Hundred Years,* a children's novel written by well-known Stockbridge resident Rachel Field. The book won the Newbery Medal for excellence in American children's literature the following year. The narrative unfolds through the eyes of a modest wooden doll named Mehitabel (Hitty), who was carved in the 19th century from "magical wood." The book details Hitty's adventures as she travels from owner to owner over the course of a century. The story was inspired by a doll actually purchased by Field. The original doll now resides at the Stockbridge Library Association Museum. The one featured in this photograph is a stand-in. It was carved by the late Ejner Handberg, a gifted cabinetmaker who built Norman Rockwell's studio. (Photograph by the author; courtesy of Anne Oppermann.)

Orville Dewey

Born in Sheffield, Orville Dewey (1794–1882) was a renowned Unitarian minister and big thinker. His ancestors were among the first settlers. Graduating from Williams College as Valedictorian in 1814, he taught school for a time in Sheffield, and then gained business experience in New York City. The ministry appealed to Dewey, and he attended Andover Theological Seminary. But he developed an antagonistic opinion of Congregational Church dogma. He quickly adopted the Unitarian Church and worked as a popular pastor in several cities. He later joined the lecture circuit and impressed listeners nationwide with his thought-provoking discussions about human life, philosophy, and religion. Beloved in his hometown, Dewey retired here, where he was visited by many of the greats of the 19th century, including William Cullen Bryant, Oliver Wendell Holmes, Nathaniel Hawthorne, and Catharine Sedgwick. Dewey also promoted the establishment of Sheffield Friendly Union, a place where locals could enjoy reading, lectures, art, education, music, games, and conversation. With help from local citizens and his Boston friends, Dewey Memorial Hall was built in 1887 and dedicated to his memory. It remains a popular gathering spot to this day. (Photograph courtesy of BerkshireArchive.com.)

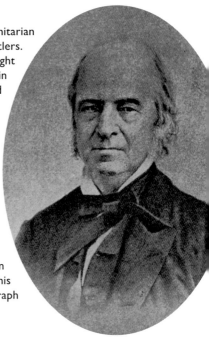

Sears Cousins

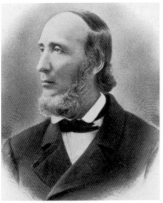

Born and raised in Sandisfield, Edmund Sears (1810–1876) is best known for writing the lyrics to the beloved Christmas carol "It Came Upon the Midnight Clear." A graduate of Harvard's School of Divinity, Sears (left) ministered to small Unitarian churches in Eastern Massachusetts. He suffered from health issues and depression. He wrote his most popular hymn during a period of personal melancholy. As an editor, author, and Unitarian theologian, Sears's numerous books were widely read. A lesser-known carol, "Calm on the Listening Ear of Night," was described by Oliver Wendell Holmes as one of the finest and most beautiful hymns ever written. Sears' deep spirituality was likely founded in Sandisfield; he once recalled that, as a child, he fancied the hilltops to rise up near heaven, where angels alighted and rested.

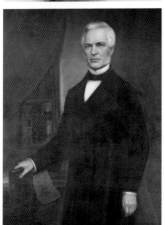

Cousin to Edmund Sears, Sandisfield native Barnas Sears (1802–1880) is considered one of the most distinguished educators of the 19th century. A graduate of Brown University, Sears first served as a professor (and later president) of the Newton Theological Seminary. He became president of Brown University in 1855 and served in that capacity for 12 years. After leaving Brown, Sears (left) represented the Peabody Educational Fund, an organization dedicated to improving education in the South after the Civil War. His efforts to boost educational opportunities for African Americans were successful largely because of his warm personality, tact, and intelligence. (Edmund Sears photograph courtesy of BerkshireArchive.com; Barnas Sears photograph courtesy of Brown University Archives.)

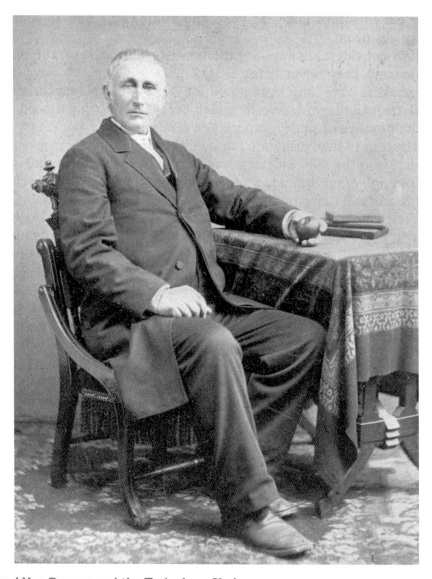

Richard Van Deusen and the Tyringham Shakers

The United Society of Believers in Christ's Second Appearing—better known as the Shakers—is a religious sect founded upon the teachings of Mother Ann Lee. One of the lesser-known Shaker communities was founded at Tyringham in 1792. In its heyday, this community had a population of over 100 who managed property totaling well over 2,000 acres. But the Tyringham society may have been better at producing strong leaders than faithful followers. By the 1850s, its numbers were greatly reduced, and by the late 1860s, it was selling off its property.

One of the most respected leaders was Richard Van Deusen (1829–1893). Born in Tyringham, he was raised by the Shakers and became an elder and trustee. When the Tyringham Shaker Village closed, Van Deusen went to the Enfield, Connecticut, Shaker community, where he was placed in charge of business and agricultural dealings. A noted horticulturist, he did much to promote the "Walter Pease" apple, and his robust fruit orchards were the envy of many. Van Deusen was also renowned as a breeder of fine cattle and, especially, horses. His untimely death hastened the collapse of the Enfield Shaker community. (Photograph courtesy of BerkshireArchive.com.)

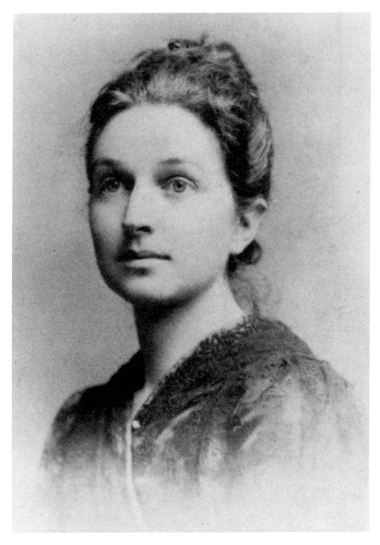

Elaine Goodale Eastman

Elaine Goodale (1863–1953) and her sister Dora Read Goodale (1866–1953) were well-known, precocious young poets who grew up at Sky Farm in Mount Washington, Massachusetts. Elaine published her first poems at age eight; while still a young teen, she and her sister gained nationwide acclaim when their beloved poems appeared in newspapers and magazines. Elaine was 15 and Dora was 12 when their first book was published, *Apple Blossoms: Verses of Two Children.* "Ashes of Roses" is perhaps Elaine's best-known poem and was set to music. In 1881, she published the well-received *Journal of a Farmer's Daughter.*

Elaine then taught at the Indian Department of Hampton Institute in Virginia, started a day school on a Dakota reservation in 1886, and was appointed superintendent of Indian education for the Dakotas Territories. Following the Wounded Knee Massacre in 1890, she cared for the injured Native Americans, along with Dr. Charles Eastman (also known as Ohiyesa), a Santee Sioux. She married Eastman and collaborated with him extensively in writing about his childhood and Sioux culture. His numerous books helped make him a featured speaker on the public lecture circuit. Elaine wrote a memoir about her experiences as a schoolteacher of the Sioux, *Sister to the Sioux.* The manuscript was published posthumously in 1978. In 2007, the film *Bury My Heart at Wounded Knee* was released, starring Anna Paquin as Elaine Goodale. (Photograph courtesy of Great Barrington Historical Society.)

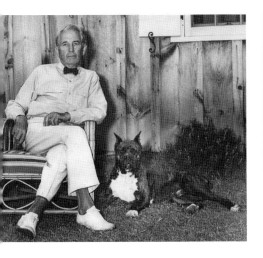

Busy Beebes

During the 19th and 20th centuries, Egremont, Alford, and Great Barrington were home bases to a medical dynasty spanning several generations. Richard Beebe (1824–1896) moved to North Egremont in 1855 and established a very successful medical practice. He later moved to Alford. He is seen at left in the 1890s. One newspaper account described Dr. Beebe as "genial, happy, magnetic . . . kind, tender and sympathetic . . . he delighted in the study of difficult and obscure cases . . . his diagnostic ability was of the first order, surpassing that of most. . . . He could easily have gained fame and fortune in a larger field, for when he was called away to distant cities his keen perception and clear opinion of complicated cases have been a surprise to some of the most renowned physicians of the day, whom he met in consultation." When the beloved doctor passed away, a local newspaper reported that the largest crowd ever seen in the village had gathered to attend his funeral. Several of Beebe's sons and grandsons also became noted physicians. John B. Beebe is seen in the top left photograph around 1944. Great-grandson George Beebe (shown above right next to his father, Dr. John T. Beebe around 1969) is well known today as a land conservationist and owner/operator of several successful farms. (Above photographs, courtesy of George and Karin Beebe; left photograph, courtesy of Great Barrington Historical Society.)

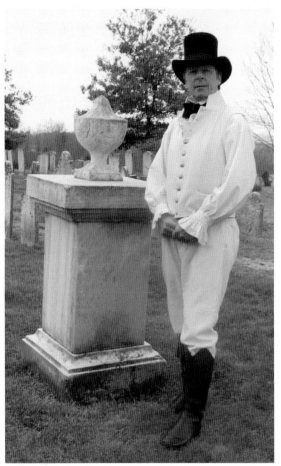

Rev. Gideon Bostwick

Gideon Bostwick served as Great Barrington's first Episcopal minister, from 1770 until his death. Throughout those tumultuous years, his courage and devotion never wavered, and he helped everyone who sought his guidance. Loyal to England during the early days of the American Revolution, Bostwick faced political intimidation. Patriots threatened him for reciting a prayer that included King George. He refused to back down, asking, is this the "boasted Assylum of Liberty?" Bostwick (1742–1793) was beloved in his community, and while other Tories were treated harshly, Bostwick was eventually allowed to travel great distances to conduct his missionary work, all the while carrying a gun for protection. Bostwick served the largest Episcopal territory in America at the time: north to Manchester, Vermont, west to Albany, New York, and south to Litchfield, Connecticut. Robert Rennie, a historical reenactor from Canada—and a direct descendant of Rev. Bostwick—visited Bostwick's tombstone at the Mahaiwe Cemetery in 2012. (Photograph by Elaine Rennie.)

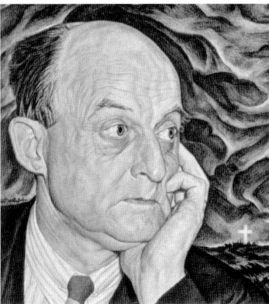

Reinhold Niebuhr

The charismatic Reinhold Niebuhr of Stockbridge was once described as "the most influential and distinguished native-born American theologian since Jonathan Edwards." (Edwards was, of course, another Stockbridge resident.) Perhaps best known for authoring the "Serenity Prayer," Niebuhr was awarded the Presidential Medal of Freedom in 1964. Among his most influential books are *Moral Man and Immoral Society, The Nature and Destiny of Man,* and *The Children of Light and the Children of Darkness.* Pres. Barack Obama said that Niebuhr (1892–1971) was his "favorite philosopher" and "favorite theologian." (Portrait by Ernest Hamlin Baker; courtesy of National Portrait Gallery, Smithsonian Institution.)

CHAPTER FIVE

It's a Tough Job, but Somebody's Got to Do It

I learned the value of hard work by working hard.

—Margaret Mead

Earning places of honor within the diverse fabric of South Berkshire are the educator, soldier, firefighter, teacher, storekeeper, historian, industrialist, servant, newsboy, commentator, humorist, jester, even rattlesnake hunter. This book's scope limits the acknowledgment of all of the hardworking residents who have lived here. But several of them have been chosen as representatives.

Look around. Hundreds of dedicated individuals strive to protect and enhance the lives of others. Consider each person in this chapter as archetypal of many others who make the community a better and more interesting place to live. For example, the discussion on the following pages of Gen. Joseph Stilwell and Brig. Gen. Robert Shea of Housatonic will call to mind all of the brave veterans who have served the country. The photograph of John B. Hull fighting the Berkshire Inn fire of 1965 is a reminder of all of the courageous firefighters, EMTs, rescue personnel, and first responders who have helped the community. Theodore Ramsdell's story is a testament to all of the mill and factory workers who struggled to build a better life for their families. Searles High School teacher and Monument Mountain High School vice principal Kate McDermott represents hundreds of dedicated teachers and educators in the community, past and present.

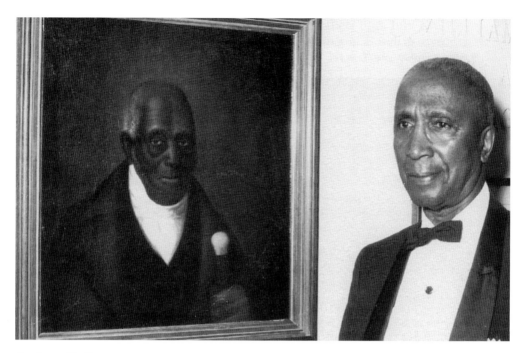

Agrippa Hull

Stockbridge resident David Gunn poses with a portrait of his famous ancestor, Agrippa Hull (1759–1848). Their likeness in this 1973 photograph is obvious. The portrait, on display at the Stockbridge Library, was painted from an 1840s daguerreotype. Hull served during the American Revolutionary War as an aide to Col. John Paterson of Lenox and to Polish general Tadeusz Kościuszko. He also helped doctors care for sick and wounded soldiers, and he was taught to perform basic operations and fix broken bones. After service in the Continental Army, Hull became the largest African American landowner in Stockbridge while working for Congressman Theodore Sedgwick. (Photograph courtesy of Stockbridge Library Association Museum.)

Joseph "Vinegar Joe" Stilwell

US Army general Joseph Stilwell (1883–1946) spent his childhood in Great Barrington. He lived on a farm along Stockbridge Road in the vicinity of what is now Stilwell Avenue. He later resided on Church Street and West Avenue. Young Stilwell was appointed to West Point from Great Barrington. He later honeymooned at the Red Lion Inn in Stockbridge and played golf at Wyantenuck Country Club. Having served in China during World War I, and for two decades afterward, "Vinegar Joe"—a nickname granted because of his feisty nature—was placed in charge of all American forces in China, Burma, and India at the outbreak of World War II. He became a legend for the masterful way his military campaigns were conducted. Stilwell, seen here with Chiang Kai-shek, is honored at the only museum in China dedicated to an American. (Photograph courtesy of US Army.)

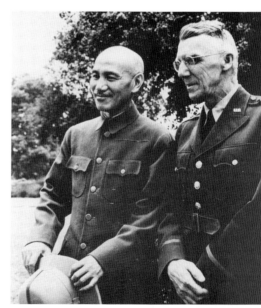

Service Personnel

These photographs were chosen as representatives of all the brave heroes who have served the country in the Armed Forces. All of them deserve thanks for their service. Featured on the right is Housatonic native Lt. Gen. Robert Shea. He served as a principal advisor to the Chairman of the Joint Chiefs of Staff and is the son of the late Emmett "Nick" Shea, Great Barrington's police chief for many years. Shown above are, from left to right, Lawrence Barbieri, Christine Ramsdell Silvernail, Peter Crawford, and Richard Jones. (Center photograph courtesy of US Marine Corps; other photographs courtesy of Great Barrington Historical Society.)

Charles Taylor

Charles Taylor was South Berkshire's most prominent historian in the 19th and early 20th centuries. He was born, lived, and died in the same house, now Finnerty & Stevens Funeral Home, on Main Street in Great Barrington. From his study in a small outbuilding that still stands (see page 85), Taylor (1824–1904) wrote his definitive *History of Great Barrington*, first serialized in the *Berkshire Courier* and then revised and published in book form in 1882. Although not without omissions and errors, the book was remarkably well researched and astonishingly detailed. Taylor was a merchant, banker, manufacturer, and also served as state representative, town selectman, and moderator. (Photograph courtesy of Bernard Drew collection.)

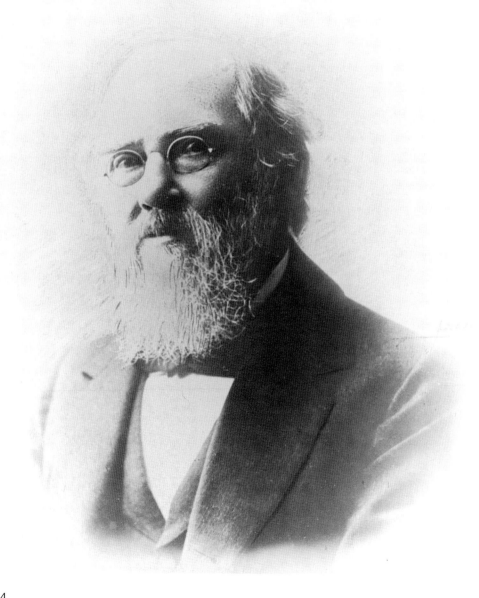

Bernard Drew and South Berkshire Historians
If Charles Taylor was the best-known local historian of the past, Bernard Drew now holds the title. For 16 years, he worked as a reporter and editor for the *Berkshire Courier*. For another 16 years, he has been associate editor of the *Lakeville Journal*. Author of *Great Barrington: Great Town, Great History* (1999), the prolific researcher and author has written several popular culture reference books and scores of fascinating local history books issued under his Attic Revival Press imprint. Modest in his efforts, Drew is a symbol for all the dedicated historians in South Berkshire, past and present, including Barbara Allen, Ronald Bernard, Brian Burke, Betty Chapin, Nic Cooper, Norton Fletcher, Edna Garnett, Dorothy Giddings, Cornelia Brooke Gilder, Robert Hoogs, Paul Ivory, James Miller, Carole Owens, Eloise Myers, James Parrish, Polly Pierce, Lillian Preiss, Thomas Ragusa, David Rutstein, Robert Salerno, John Sisson, Virginia Siter, Joseph Poindexter, Barbara Swann, Grace Wilcox, Henry Wingate, and Lynn Wood, to name just a few. (Photograph by the author.)

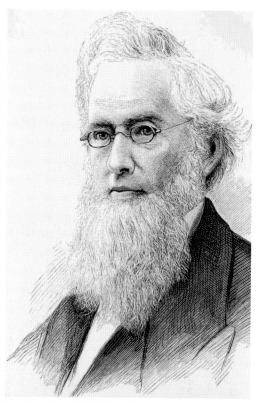

The Barnard Brothers

The Sheffield-born Barnard brothers, both suffering from hereditary deafness, went on to great success in their chosen fields. Both never forgot their roots, and they returned to Sheffield in retirement.

Dr. Frederick Barnard (left) was a versatile educator in the fields of science, English, and mathematics. After graduating from Yale, he taught at the American Asylum of the Deaf in Hartford, and then at a similar institute in New York City. He became president of the University of Mississippi until the outbreak of the Civil War. Barnard (1809–1889) worked for a time in the field of astronomy and mapmaking until taking the reigns as president of Columbia College. During his 25-year tenure, Columbia grew from a tiny undergraduate college into one of the nation's great universities. A relentless advocate of equal educational opportunities for women, Barnard College was named in his honor.

Gen. John Barnard (1815–1882) had an impressive career as an officer in the US Army. A West Point graduate, Barnard began his career in the Army Corps of Engineers, providing effective leadership during the Mexican-American War. In 1856, he took over as superintendent of the US Military Academy, succeeding Robert E. Lee. When the Civil War broke out, Barnard was put in charge of fortifications around Washington, DC. He then served as chief engineer for the Army of the Potomac and on the staff of Gen. Ulysses S. Grant until the surrender of Confederate forces at Appomattox in 1865. John Barnard (left) proudly served as an honor guard at President Lincoln's funeral. He then dedicated the rest of his life to the Army Corps of Engineers, making river and harbor improvements, serving on the US Lighthouse Board, and authoring numerous engineering treatises and Civil War history papers. (Above, lithograph from *Popular Science*; below, photograph courtesy of Library of Congress.)

Roger the Jester

Roger Reed describes himself as "a fool for all reasons." When not performing, he lives a quiet life in Egremont. But when laughter is required, Reed dons his multistriped skullcap, bright green shorts, mismatched socks, and red cow suspenders. He hops into his green Volkswagen Beetle and heads out on another important mission of mirth. Originally trained as a photojournalist, Reed discovered his inner jester over three decades ago on the streets of Boston. He later joined the legendary Swiss theater mime troupe Mummenschanz on Broadway. Reed then took to the road to "recreate the wandering lifestyle of a medieval fool." For several years, he blazed a highway of high jinks through 23 countries. In 1993, Reed decided to base his buffoonery in the Berkshires, and he settled down here with his wife and family. He is no fool! (Photograph by David Moulthrop.)

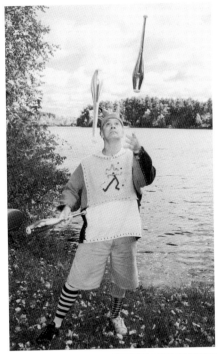

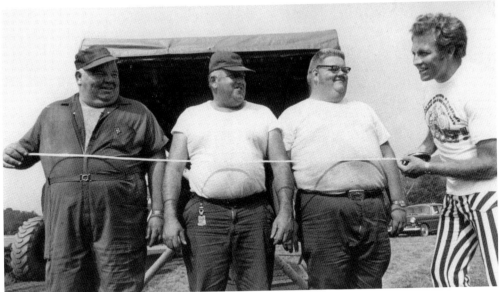

Bullet and Lee Kline

William "Bullet" Kline (1924–2002) and his son H. Lee Kline (1948–1996) were two big boys known for their generosity and hearty appetites The well-liked pair worked together on their farm near the Great Barrington airport and operated a tractor, plowing, harvesting, and property-maintenance business. The Great Barrington Fair was one of their clients, and the father-son team was a staple there during fair week. In the early 1970s, legendary daredevil Evel Knievel (far right) prepared to jump his motorcycle over, from left to right, Bullet Kline, Francis Van Deusen, and Lee Kline. (Photograph courtesy of Great Barrington Historical Society.)

87

Kathleen "Kate" McDermott

Kate McDermott (1915–1984) was a longtime teacher as well as vice principal of Searles High School and Monument Mountain Regional High School in Great Barrington. A lifelong resident of Housatonic, McDermott's stellar career in education spanned 42 years. She received numerous awards, including Outstanding Citizen and the statewide Vice-principal of the Year. McDermott was considered by many to be the "power behind the throne" in the school district. She was a loyal friend to colleagues, respected by all, and feared by a few who dared cross her. She cared deeply about her students and was not afraid to gently bend the rules to properly administer justice. Dr. Alan Chartock, president of WAMC Northeast Public Radio, said it best when he wrote, "she was my hero." (Photograph courtesy of Great Barrington Historical Society.)

Elizabeth Blodgett Hall

In 1964, education pioneer Elizabeth Blodgett Hall (1909–2005) founded the nation's first "early college," now known as Bard College at Simon's Rock. Earlier in her career, Hall served as head of the history department, then headmistress, at Concord Academy in Massachusetts. Hall envisioned a learning environment for bright, highly motivated students ready to begin college immediately after the 10th or 11th grade. To help make her dream come true, Hall made a significant financial commitment and gave 200 acres of her family's farmland, buildings included, to start the college. She named it for a rock on which she had played as a child. (Photograph by Marie Tassone.)

Joe and Craig Elliott
Joe Elliott (1907–1972) was held in high regard in Egremont. He ran the North Egremont general store for exactly 36 years, from 1936 until 1972. His son Craig then took over and operated the store for another 36 years! Joe (shown here) was also the village postmaster, unofficial "mayor" of North Egremont, and dowser extraordinaire. As the elder Elliott often said, "It's my job to keep everybody happy." He was largely successful, as was his son. Joe was also a local historian particularly interested in the legendary route Col. Henry Knox took while transporting cannons from Fort Ticonderoga to Boston during the early days of the American Revolution. Knox Trail markers had been incorrectly placed in Columbia County, New York, and Joe worked for years to get the error fixed. (Photograph courtesy of Craig Elliott.)

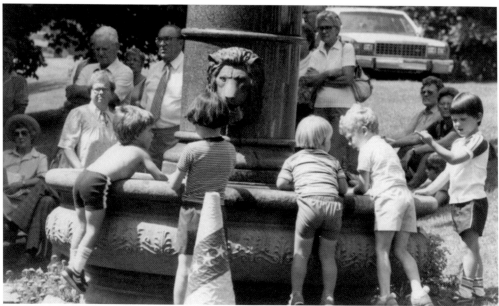

The *Newsboy* (ABOVE AND LEFT)
Since 1895, the Great Barrington *Newsboy* statue, tarnished by the tears of time, has watched life pass by in the fast lane of Route 23. Col. William Lee Brown, who had a large home on nearby Silver Street and was part owner of the first *New York Daily News*, gave the Newsboy to the town. Ornate spigots on the base supplied separate drinking fountains for horses, dogs, cats, and humans. The bronze-skinned waif survived a devastating tornado in 1995, just a few months before a 100th birthday celebration was held in his honor. (Photographs courtesy of BerkshireArchive.com.)

Isaac "Ike" Whitbeck

Ike Whitbeck (1862–1925) of Mount Washington had a profitable but risky sideline career when he was not delivering mail for the US Post Office Department. He captured and sold rattlesnakes. One of his regular clients was Raymond Ditmars, reptile curator at the Bronx Zoo. Whitbeck achieved nationwide attention in the press and was billed as "king of the rattlesnake handlers." He claimed to have captured as many as 50 rattling reptiles on one outing, carrying them home in a heavy burlap bag. In this photograph, Whitbeck holds a sizable snake with a homemade set of long-handled tongs. (Photograph courtesy of Great Barrington Historical Society.)

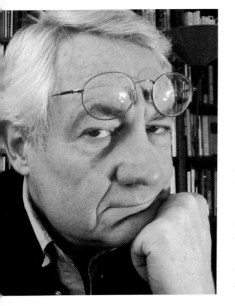

Roy Blount Jr.

Time magazine once described Roy Blount's writing and antics as being "in the tradition of the great curmudgeons like H.L. Mencken and W.C. Fields." In South Berkshire, Blount generally behaves himself as a resident in Mill River. Formerly a staff writer and associate editor for *Sports Illustrated*, Blount has written hundreds of articles and columns, numerous books, and is past president of the Author's Guild. His writing covers a wide range of topics, from the Marx Brothers to what barnyard animals are thinking. He has appeared frequently on *A Prairie Home Companion*. The show's host, Garrison Keillor, once said, "He can be literate, uncouth and soulful all in once sentence." Blount is also a popular panelist on NPR's popular news quiz show, *Wait, Wait . . . Don't Tell Me*. He is married to award-winning artist Joan Griswold, another Berkshire favorite. When he is not hanging out in the Berkshires, Blount's life seems a bit fishy. He has scuba-dived with sharks, caught catfish with his bare hands, and, while rafting the Amazon, fought off piranha. (Photograph by Joan Griswold.)

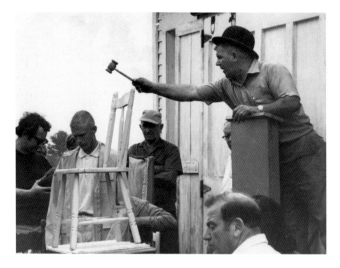

Francis X. "Frank" Mackoul
Antiques dealer and auctioneer extraordinaire Frank Mackoul (1929–2012) had a surefire way to get people's attention. He gave 'em the gavel! In the 1970s, great bargains could often be had at Mackoul's entertaining auctions and, later, at his antiques sales. Rumor has it that this rare Shaker chair sold for just $10. Only kidding. (Photograph by Marie Tassone.)

Leamon Roger and Raymond Kotleski
Leamon Roger (1919–2006), shown on the left, and Raymond Kotleski (1922–2000), shown on the right with Rachel Fletcher, were popular South County trash haulers and recyclers held in high regard by their many customers. Perhaps that is because they rarely "talked trash" about anyone. In fact, both gentlemen quietly helped folks in need, and they rarely spoke of their acts of kindness. (Photographs by Bernard Drew.)

Ethan Allen

Although the name Ethan Allen is now synonymous with fine furniture, he probably had little time to craft cabinets. For 10 years, Allen was a resident of Sheffield, with three of his five children born here. He labored as a farmer, land speculator, author, philosopher, and feisty American patriot. Allen (1738–1789) is perhaps best known as the leader of the Green Mountain Boys, who captured Fort Ticonderoga at the start of the American Revolution. Local historian Morgan Bulkeley wrote that Allen was a "mixture of Robin Hood and Aristotle who swung from stormy action to philosophic contemplation with little patience for anything in between." He often left his family behind in Sheffield, preferring to play "hardball" as a land speculator. Allen often embarked on campaigns of intimidation in an attempt to drive rival New York settlers out of Vermont. He wrote interesting accounts of his exploits that were widely read in the 19th century, posthumously creating a legendary name still well known today. (Photograph courtesy of Great Barrington Historical Society.)

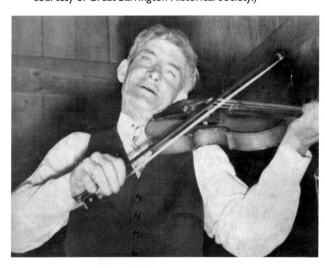

Samuel "Sammy" Spring

Farmer by day, musician by night, Sammy Spring (1883–1958) of Otis was a fiddling phenomenon for decades. A popular square-dance caller, he was in high demand throughout New England and beyond. Every week, upon completion of his farm chores, he drove to Hartford to play on WTIC radio's evening broadcast. His busy schedule included regular appearances at local venues like the Otis Grange hall, Jacob's Pillow, and the Storrowtown Club in West Springfield. But Spring also fiddled at the Hotel McAlpine in New York City, the Hotel Statler in Boston, and Radio City Music Hall. He gained worldwide attention when he played at the National Folk Festival in Washington, DC, in 1939. He even "sawed the strings" for three First Ladies: Grace Coolidge, Lou Hoover, and Eleanor Roosevelt. (Photograph courtesy of Ronald Bernard.)

Southern Berkshire Firefighters

This dramatic photograph was chosen to represent all of the brave firefighters in the Southern Berkshires who strive to keep residents safe. Here, fireman John B. Hull III aims at the flames during the 1965 Berkshire Inn fire on Main Street in Great Barrington. (Photograph by Elmer Lane.)

Theodore Ramsdell and Sons

Theodore Ramsdell (1833–1903) was vice president and a major stockholder of Monument Mills textile company in Housatonic for many years. His sons, T. Ellis and Thomas, both served as president of the company. Together, the family worked at the mills for nearly a century. The elder Ramsdell was held in high regard by local residents, and he often expressed an interest in their welfare. After his death, Ramsdell's wife and four children took pleasure in carrying out his promise to pay for the construction of a library in Housatonic. In 1908, the handsome Ramsdell Library opened, and it remains a popular gathering spot today. (Photograph courtesy of BerkshireArchive.com.)

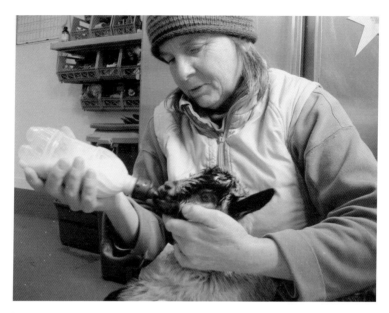

Sellew Siblings

Susan Sellew and her brother Sanjiban (1954–2012) are South Berkshire legends. Susan is the owner of Rawson Brook Farm in Monterey, which is celebrating its 30th anniversary. Her famous Monterey Chevre is a soft goat cheese made exclusively by her. Susan built the farm from scratch with family land and a few goats. An organic farmer, she was a local pioneer in what is now called the "sustainable agriculture movement." She seems to know every billy and nanny by name—remarkable, considering there are over 100 on hand at all times.

Sanjiban (below) was a much-beloved Berkshire filmmaker, artist, actor, cabinetmaker, and humorist. Perhaps best known (with his brother John and cousin Sam Mills) as one of the comedic "Konkapot Big Boys," Sellew's award-winning, quirky films and performance art were enjoyed at local and regional film festivals, on stage, and at numerous venues over several decades. (Above, photograph courtesy of Rawson Brook Farm; below, photograph by Cynthia Atwood.)

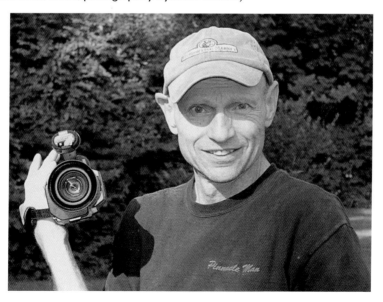

CHAPTER SIX

Artists, Activists, and Athletes

It had long since come to my attention that people
of accomplishment rarely sat back and let things happen to them.
They went out and happened to things.

—Leonardo da Vinci

This alliteratively titled chapter gathers folks with wide-ranging backgrounds and talents. The Southern Berkshires have long attracted painters, writers, sculptors, musicians, filmmakers, and composers. Political, environmental, and human rights activists have always felt motivated and inspired here. Many incredibly talented athletes grew up in this fitness mecca, while others made the wise choice to move here. An entire book could not do justice to them all. A mere chapter can only scratch the surface.

Each person in this section should be viewed as a symbolic representative of the many amazing residents who have strived and succeeded in their aspirations. For example, when you see the photograph of Housatonic River guardian Rachel Fletcher, think also of political activist and commentator Mickey Friedman. When you read about cellist Yo-Yo Ma, remember talented music educator and trumpeter Jeffrey Stevens. The lovely photograph of dancer Olga Dunn also symbolizes the style, grace, and talent of other local dancers and dance educators like Dawn Lane, and Bettina Montano of Berkshire Pulse. The photograph of brilliant baritone Benjamin Luxon of Sandisfield also honors Great Barrington soprano Phyllis Curtin, Housatonic musician Bobby Baier, and Sheffield's John Hoyt Stookey, founder of Berkshire Choral Festival. The late folk singer Richard Dyer-Bennet of Monterey should also be remembered. The image of artist of Michael McCurdy also honors other beloved artisans like Shelly Fink and Sheffield's paper sculptor genius Seymour "Rob" Robins.

When viewing the photographs of race car driver Dickie Larkin or present-day superstar Andy Bachetti, also remember the great Eddie Delmolino, who made many trips to the winner's circle. When you ponder the efforts of artists like Norman Rockwell in Chapter One, or Yvonne Twining Humber in this chapter, also remember the many talented artists living here like Deb Koffman, Kate Knapp, Eunice Agar, and the late Frank Packlick, to name just a few. Plus, "artistic souls" like Laurie Norton Moffatt of the Norman Rockwell Museum and Kelley Vickery of the Berkshire International Film Festival who make access to artistic treasures possible.

And when you look at the classic images taken by photographer Donald Victor, think about the amazing array of other talented photographers living here—like John Stanmeyer, Gregory Cherin, Lee Rogers, Michael Lavin Flower, Stephen Donaldson, and dozens more.

Rachel Fletcher

Rachel Fletcher lives in two worlds that initially seem geometrically opposed. On any given day, she might be found outdoors, slogging through shallows in the Housatonic River, picking up trash. Mere hours later, she might be intently focused on a computer screen, exploring the complexities of geometric proportion and design. Fletcher began her career in lighting and stage design for the theater. She taught theater design at Tufts University and has been a faculty member of the New York School of Interior Design since 1996. Her professional work led to an interest in the principles of geometric proportion and harmony as a design system.

Most of her adult life has been focused on improving the world, both indoors and outdoors. As a community activist, she is the founding director of the Great Barrington Housatonic River Walk and the founding codirector of the Upper Housatonic Valley African American Heritage Trail. She has been very active in developing and improving the W.E.B. Du Bois Boyhood Home site, a National Historic Landmark in Great Barrington. She has received many national honors, including an Environmental Merit Award from the US Environmental Protection Agency. (Photograph by Steve Moore; courtesy of Rachel Fletcher.)

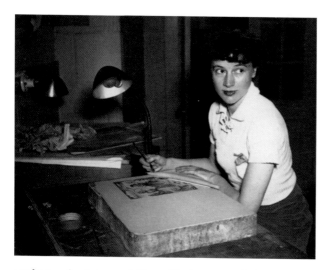

Yvonne Twining Humber

The career of painter Yvonne Twining Humber (1907–2004) was nurtured in Egremont and matured in Seattle, Washington. She was the daughter of Emma Potts Twining, an internationally known opera singer (stage name, Mademoiselle d'Egremont) originally from South Egremont. The sudden death of Yvonne's father when she was only 10 forced an abrupt end to her family's international living. With greatly reduced income, Yvonne and her mother returned to South Egremont. Yvonne Twining exhibited impressive artistic talent at a young age and was fortunate enough to have professional artists as neighbors. She later attended the National Academy of Design and won two Tiffany Foundation fellowships, spending time with the legendary designer Louis Comfort Tiffany.

As Twining's talent matured, the Great Depression of the 1930s worsened. When the government-sponsored WPA Federal Arts Project began, Twining worked as an easel painter from 1935 to 1943. During this time, she established a national reputation for her rural and urban subject matter. Her paintings were frequently praised by critics. She supplemented her meager income with freelance projects, including illustrations for an innovative real estate development company known as the Olde Egremont Association.

In 1943, Twining married 45-year-old Seattle businessman Irving Humber after knowing him just a few weeks. It was an arranged marriage orchestrated by her mother and aunt. Twining's income had ceased when the WPA program ended, and they considered Humber a suitable provider for the 35-year old artist. After her move to Seattle, Twining Humber's career skyrocketed, with one-woman shows and national awards from organizations such as the Smithsonian Institute. Her painting of Rising Paper Mill in Housatonic is shown below. At the height of her artistic powers, an unfortunate series of family tragedies forced Humber to stop painting.

In 1976, the nation's bicentennial ushered in a retrospective interest in the WPA art projects, especially those of the few women artists who had worked in the program. Twining's paintings and talent gained favorable notice in several East Coast exhibitions. She continued painting well into her 90s. Before her death, she created the Twining-Humber Award for Lifetime Achievement, giving an annual $10,000 prize to a Washington state female artist over the age of 60 who has dedicated a substantial portion of her life to art. Twining Humber maintained a lifelong love of the Southern Berkshires; after her death, she was buried in the little South Egremont cemetery just down the street from her old home. (Above, photograph courtesy of Martin-Zambito Fine Art; right, painting by Yvonne Twining Humber, courtesy of Great Barrington Historical Society.)

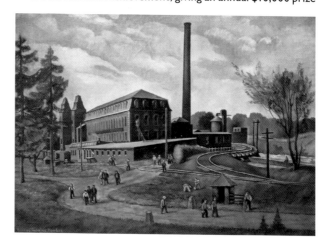

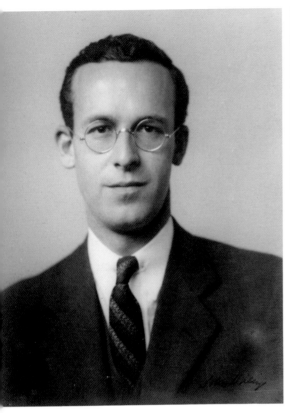

Morgan Bulkeley III

Naturalist, writer, and historian Morgan Bulkeley was a beloved resident of Mount Washington, Massachusetts. His ancestral namesake was governor of Connecticut and president of Aetna Life Insurance Company. After graduating from Yale University, Bulkeley worked for Aetna for a time, but he longed for a rural life. Similar to his hero, Henry David Thoreau, Bulkeley moved into a small cabin on Mount Washington's Plantain Pond in the 1930s. One day, while on a walk, he met his future wife, Barbara Van Deusen, while she was riding her horse on a trail. They were married in 1941 and operated a farm on the mountain while raising two children. Bulkeley (1913–2012) was a knowledgeable ornithologist and botanist, and he was known for rescuing a menagerie of wild animals. He studied with poet Robert Frost, and in 1960, he began writing a history and nature column for the *Berkshire Eagle* entitled "Our Berkshires." Some of his writings were later turned into a popular book, *Berkshire Stories*, which was cleverly illustrated by his son and namesake. Bulkeley worked tirelessly for the Trustees of Reservations and served on the board of the Berkshire Museum. A degenerative eye disease left him blind in his later years. Bulkeley's friends and neighbors—both human and animal—loved him. (Photographs courtesy of Morgan Bulkeley IV.)

William Gibson

William Gibson (1914–2008), a Tony Award–winning playwright and novelist from Stockbridge, was best known for *The Miracle Worker*, the inspirational story of Helen Keller and her teacher, Anne Sullivan. Known for the demanding roles he wrote for women, Gibson's scripts and screenplays helped make stars out of Anne Bancroft and Patty Duke. *Golda's Balcony*, a work about the late Israeli prime minster Golda Meir and starring Tovah Feldshuh, set a record as the longest-running one-woman play in Broadway history. (Photograph by Ed Ford; courtesy of Library of Congress.)

Arthur Penn

Longtime Stockbridge resident Arthur Penn (1922–2010) was a critically acclaimed stage, television, and film director perhaps best known locally for his Berkshire-based 1969 film *Alice's Restaurant* starring Arlo Guthrie. A pioneering director of live television drama in the 1950s, Penn became a Broadway and motion-picture heavyweight in the 1960s and 1970s. He teamed up with his Stockbridge neighbor, playwright William Gibson, to direct the Helen Keller biopic *The Miracle Worker,* first for television, and then Broadway and film versions. Penn advised John F. Kennedy during the Nixon-Kennedy debates of 1960, but arguably left his biggest mark in film with his innovative directing of the controversial motion picture *Bonnie and Clyde*, starring Warren Beatty and Faye Dunaway. This photograph was taken at a historical exhibit of Berkshire filmmakers. The cover of the book shown (written by Robin Wood) features Geoff Outlaw and Arlo Guthrie in the Stockbridge jail during the filming of *Alice's Restaurant*. (Photograph courtesy of Great Barrington Historical Society.)

Hilda Banks Shapiro

Octogenarian Hilda Banks Shapiro, a piano prodigy, remains one of South Berkshires' busiest musicians. She began at the New England Conservatory in Boston at age eight, studied with pianists Leonard Shure and Arthur Schnabel, and was the youngest student accepted at Berkshire Music Center (Tanglewood). She was chosen by Serge Koussevitzky to play piano as student representative with the Boston Symphony Orchestra. She married Leonard Shapiro, ran a farm, and raised 12 children. She later returned to music and teaching. Involved in numerous community activities, Shapiro remains a beloved musical whirlwind of talent and kindness. (Photograph by Donald Victor.)

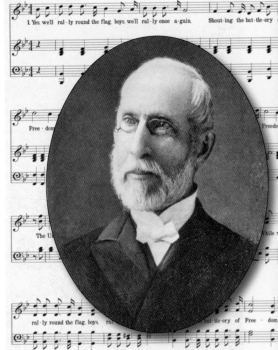

George Root

Songwriter and music education pioneer George Root (1820–1895), born in Sheffield, was a descendant of early settlers. Although he left town in his youth, he kept in touch with family and friends, returning for visits and to give concerts. From an early age, Root showed remarkable musical abilities, mastering 13 instruments by the age of 12. A popular and prolific songwriter during the Civil War, he wrote classics such as "The Battle Cry of Freedom" and "Tramp! Tramp! Tramp!" Root co-owned a successful music publishing company in Chicago. He taught music and singing and became renowned for training music teachers around the country. Some of Root's popular melodies were set to new lyrics in the latter 20th century, including the well-known "Jesus Loves the Little Children." (Composite photograph courtesy of BerkshireArchive.com.)

Karen Allen

Karen Allen has long been part of the fabric of the Southern Berkshires. She is known and respected here as much for her yoga skills and textile designs as she is for her award-winning acting. She is the proprietor of Karen Allen–Fiber Arts Studio on Railroad Street in Great Barrington. Ancient geometric patterns inspire her remarkably beautiful, handmade knitware, crafted in vibrant colors from the highest-quality cashmere yarns. Allen made her film debut in *National Lampoon's Animal House* and is beloved as Indiana Jones's companion in *Raiders of the Lost Ark* and *Indiana Jones and the Kingdom of the Crystal Skull*. She has appeared in dozens of films, many television programs, and numerous theatrical productions. (Photograph by Lisa Levart.)

Cynthia Wade

Cynthia Wade of Egremont won the 2007 Academy Award and 16 additional film awards for her HBO documentary *Freehold*, about a dying policewoman fighting to leave her pension to her female life partner. In 2013, she received her second Oscar nomination for *Mondays at Racine*, about a hair salon that caters to women undergoing chemotherapy. Wade's 2010 documentary *Born Sweet,* about a Cambodian village poisoned with arsenic well water, won 17 festival awards at Sundance, Palm Springs, Aspen, and Newport. Her 2004 HBO film *Shelter Dogs,* about the ethics of euthanasia at a rural animal shelter, won five festival awards and was broadcast in seven countries. Locally, she produced a commercial starring Egremont poet and nonagenarian Stanley Farnum and featuring his L.L. Bean boots. Most recently, Wade made national headlines with her locally produced documentary *Selfie,* in which teenage girls and their mothers are challenged to take honest smartphone self-portraits. (Photograph by Joshua Paul.)

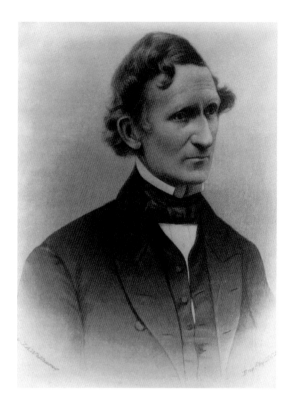

Elihu Burritt

Known as the "Learned Blacksmith," Elihu Burritt (1810–1879) rose from humble roots to attain international significance. Although Burritt lived in New Marlborough for only two years, working as a blacksmith, his name remains one of the best known in town, with a community fair held in his honor each summer. By the age of 30, Burritt had mastered 50 languages. He wrote and published voluminously and lectured on a variety of humanitarian subjects, all the while supplementing his income as a blacksmith. Burritt, an abolitionist, traveled the globe advocating for world peace. He organized the International Congress of the Friends of Peace, a precursor to the United Nations. Pres. Abraham Lincoln appointed Burritt as US consul at Birmingham, England. An anvil-topped monument to the Learned Blacksmith honors Burritt on the green in New Marlborough. (Photograph courtesy of BerkshireArchive.com.)

John H. Coffing and "Vicky"

Strong-willed industrialist John H. Coffing (1811–1882) usually got his way in Great Barrington. He was described by colleagues as assertive but genial, with a masterful personality and strong business acumen. He ran the iron foundry in Van Deusenville, was co-owner of Monument Mills, and served as director of two banks. He even attended the national convention in 1860 that nominated Abraham Lincoln for president. But Coffing's longest-standing legacy still greets passers-by in front of town hall. For it was Coffing who promoted and helped design and pay for the *Winged Victory* Civil War monument. In an era when most statues of this type featured a traditional likeness of a soldier, Coffing wanted something more symbolic and artistic. He got his way, and today "Vicky" (a nickname granted to her in recent years) has been restored to her original grandeur, alighting upon a golden globe, holding an olive branch in one hand and a crown of victory in the other. (John Coffing lithograph courtesy of BerkshireArchive.com; *Winged Victory* photograph by Donald Victor.)

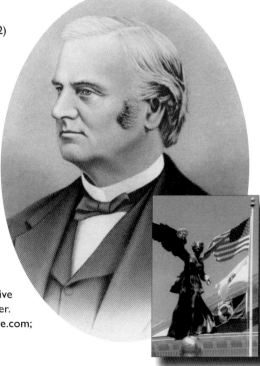

Simon Winchester

Simon Winchester is a best-selling author and journalist who resides in Sandisfield with his wife, former National Public Radio producer Setsuko Sato. Born and raised in Great Britain, he has traveled the world, but he now calls Southern Berkshire home. Originally a geologist, Winchester's first assignment found him searching for copper deposits in Uganda. He made an abrupt career change in the late 1960s, switching from rocks to writing. As a globe-trotting journalist, he covered numerous historic events, including the unrest in Northern Ireland, the Watergate scandal, and the Falklands Islands invasion, where he was unjustly jailed as an alleged spy. His work took him to Hong Kong, where he was an editor, contributing to *Condé Nast Traveler*, *National Geographic*, and *Smithsonian* magazines. His award-winning books include *The Map that Changed the World*, *The Meaning of Everything*, *Krakatoa: The Day the World Exploded*, *A Crack in the Edge of the World*, *The Man Who Loved China*, and, most recently, *The Men Who United the States*. Locally, he is also known as the founder of the well-written *Sandisfield Times* newsletter. (Photograph by Roberta Myers; courtesy of Ronald Bernard.)

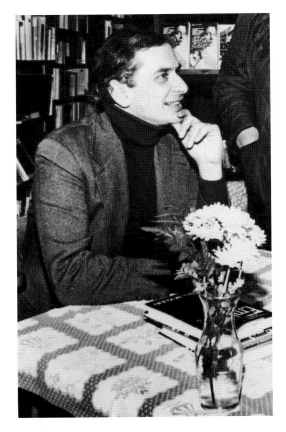

Daniel M. Klein

Dan Klein came to the Southern Berkshires in 1974 to work on a television script, and he could not think of any good reason to return to New York. So, he did not. He believes it was one of the best decisions he ever made. Originally a television comedy writer, Klein is the award-winning author or coauthor of more than 30 books, including *Plato and a Platypus Walk into a Bar* and *Macho Mediations*. His novel *The History of Now* takes place in Grandville, a town that bears more than a passing resemblance to Great Barrington. He has also penned several thrillers and mysteries, including the Elvis Presley detective series. Klein is married to prominent Dutch journalist Freke Vuijst. (Photograph by Donald Victor.)

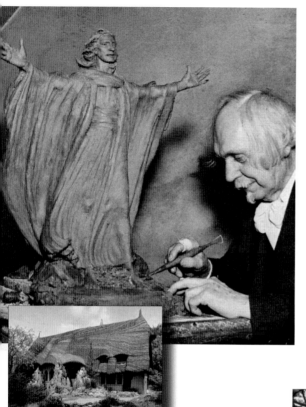

Henry Hudson Kitson

Henry Hudson Kitson (c. 1864–1947) was a renowned sculptor who lived in Tyringham. His works include *The Minute Man* in Lexington, *Pilgrim Maiden* in Plymouth, *Roger Conant* in Salem, and *Robert Burns* in New York City. In the 1920s, Kitson began transforming a barn on his property into a sculpture studio. It was this project that consumed the last 25 years of his life and his finances. The most striking feature of Kitson's unusual studio is its 80-ton, thatch-like shingled roof. Each shingle was hand-cut into a wavelike shape and then laid in thick layers of different colors. Some say they can see a witch's face in the front part of the roof. He named his studio Santarella, but it is well known as the "Gingerbread House." (Kitson photograph by Arthur Palme; Santarella photograph courtesy of Berkshire Historical Society.)

Yo-Yo Ma

Yo-Yo Ma is the most widely recognized and beloved cellist in the world. He and his family (including his prized cello, Petunia) live in Tyringham and are active members of the community. Ma began studying the cello seriously at age four, and as a child prodigy, he performed for Presidents Dwight Eisenhower and John F. Kennedy. Over the years, he has worked with most of the world's major orchestras and has been featured on several movie soundtracks. He was a key player during Tanglewood's 75th-anniversary season. Ma is artistic director of the Silk Road Ensemble, which brings together musicians from diverse countries and is committed to education programs and humanitarians causes. He has earned numerous awards, including the Presidential Medal of Freedom. He has recorded over 75 albums and won more than 15 Grammy Awards. (Photograph by Robin Young, host of the nationally syndicated public radio show *Here & Now*.)

James Weldon Johnson

James Weldon Johnson (1871–1938) was an African American writer, educator, lawyer, diplomat, civil rights activist, and author. In 1926, Johnson purchased a summer home in the Seekonk section of Great Barrington. He frequently wrote at a table in the Mason Library and, being very well liked, was often greeted by friendly residents. He built a separate "writing cabin" (shown here) on his property so that he could work uninterrupted.

Theodore Roosevelt appointed Johnson US consul to Venezuela and then Nicaragua. He taught at New York University and Fisk University. He became a leading voice in the Harlem Renaissance and served as an effective leader within the NAACP. He composed the lyrics for "Lift Every Voice and Sing," which became known as the Negro National Anthem. One of his most celebrated works is his collection of poems *God's Trombones: Seven Negro Sermons in Verse*, much of which he wrote in Great Barrington. Sadly, Johnson's life was cut short when the car he was driving was hit by a train. (Photograph courtesy of Beinecke Rare Book & Manuscript Library.)

Walter Prichard Eaton

Walter Prichard Eaton (1878–1957) was a well-known author, drama critic, and professor at Yale University who lived in Sheffield. His novel *The Idyl of Twin Fires* (1914) helped inspire a back-to-nature movement. He wrote numerous books about the theater, but he is perhaps best known in the Berkshires for his nature writing, with books like *In Berkshire Fields*. His *Boy Scouts of Berkshire* (1912) and sequels endeared him to a generation of young readers. (Photograph courtesy of Sheffield Historical Society.)

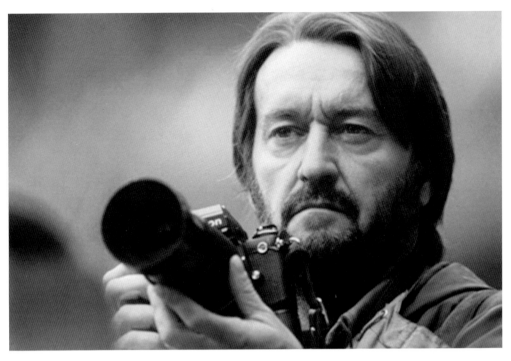

Ken Regan
In the world of photography, Otis resident Ken Regan (d. 2012) is nearly as legendary as the subjects that appear in his snapshots. His career began in the sports arena, where he covered the Olympics, World Series, Super Bowls, and many other professional sports. His photographs have appeared on the cover of *Time, Life, Sports Illustrated, Entertainment Weekly,* and *Newsweek.* He traveled worldwide, covering riots and demonstrations, concerts, fundraisers, and political and sporting events. His iconic images include the Rolling Stones, Muhammad Ali, Hank Aaron, Bob Dylan, Joan Baez, and Johnny Cash. The author of several books, Regan's 2011 volume *All Access: The Rock 'N' Roll Photography of Ken Regan* received rave reviews. Locally, his photographs hang on the walls of the Dream Away Lodge in Becket, showcasing a legendary party held there in 1975. He was also a staunch supporter and champion of Kelley Vickery's Berkshire International Film Festival. (Photograph courtesy of Camera 5.)

Carrie Smith Lorraine
Carrie Smith Lorraine (1868–1935) was Sheffield's first female professional photographer as well as the proprietor of Orchard Shade Guest House. She left behind over 1,000 incredible glass-plate negatives that captured life in the Southern Berkshires at the turn of the 20th century and beyond. Lorraine photographed tourists, residents, buildings, farms, animals, children, and special events, often with a subtle mood of playfulness. (Photograph courtesy of Sheffield Historical Society.)

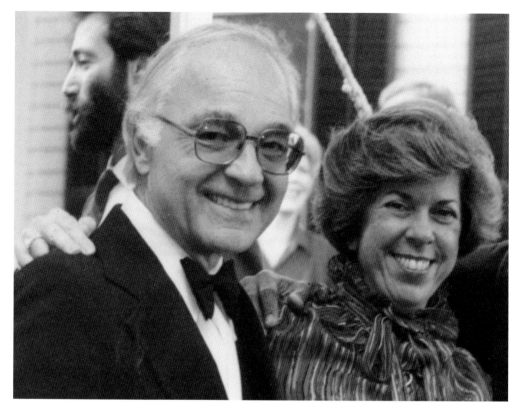

Aaron and Abby Schroeder

Aaron Schroeder (1926–2009) wrote songs that spanned generations and garnered gold and platinum records for decades. He had scores of hits by musical legends like Elvis Presley, Carl Perkins, The Beatles, Roy Orbison, Frank Sinatra, Art Garfunkel, Barry White, Chaka Khan, Dionne Warwick, Julio Iglesias, Tramaine Hawkins, and Usher.

Aaron stands among the rare and distinguished songwriters selected by *Billboard* magazine on its 100th anniversary for writing one of the top 100 songs on its greatest hits charts. "It's Now or Never," recorded by Elvis Presley, holds the No. 75 position. It is the all-time best-selling single by Presley.

As an international music publisher, Aaron holds an enviable record for discovering, guiding, and developing such great composers and lyricists as Randy Newman, Barry White, Irwin Levine, Jimi Hendrix, Al Kooper, and Gene Pitney. He also produced the first album by the legendary Blood, Sweat & Tears.

Aaron founded Musicor Records, a forerunner of the independent labels to be distributed by major companies worldwide. He produced the hit record "Town Without Pity" by Gene Pitney, the first pop song to be performed at the Academy Awards. He also teamed Pitney with the new songwriting team of Burt Bacharach and Hal David, resulting in a string of Pitney hits, including "The Man Who Shot Liberty Valance" and "Only Love Can Break a Heart."

At age 22, Abby Schroeder became the youngest woman executive at the top level of the music industry, as CEO of A. Schroeder International LLC. The company is known worldwide for innovative publishing practices and record production. She has brokered deals with major Broadway shows, films, and Las Vegas shows. She has also negotiated major media contracts with numerous companies and served as music supervisor for motion pictures and television series. During a 20-year relationship with the Berkshire Theatre Festival, she executive-produced benefit shows honoring such legends as Marvin Hamlisch, Betty Comden, and Burton Lane. She also produced the 2010 and 2011 Actors Fund Benefit Galas in New York City, and she is currently an officer of the Actors Fund board. (Photograph courtesy of Donald Victor.)

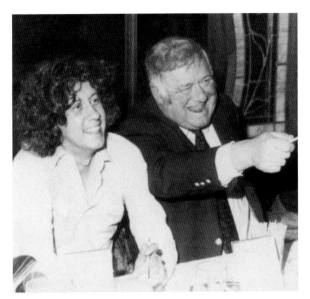

Arlo, Alice, and Officer Obie
On Thanksgiving weekend in 1965, Stockbridge police chief William Obanhein arrested young Arlo Guthrie for improperly disposing of garbage. Guthrie later embellished the event in his legendary song "Alice's Restaurant Massacre." In 1969, the sanitation saga was made into a motion picture—now considered a cult classic—also featuring Alice and Ray Brock. Chief Obanhein, better known as "Officer Obie," played himself in the film. Guthrie and Obanhein became friends while making the movie and later teamed up as judges at a local bartending contest. (Photograph by Edgar Zukauskas; courtesy of Alfred Lenardson.)

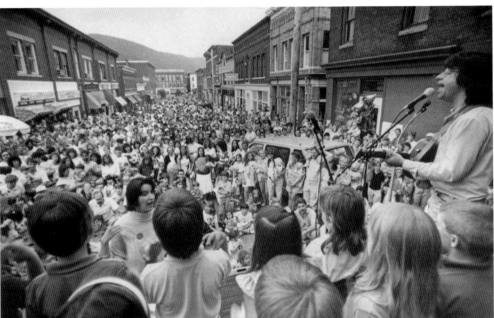

David Grover
David Grover has lived in several South County towns over the years, but his music has been heard and appreciated worldwide. He has performed at the White House, appeared on major television programs, including his own PBS specials, and won numerous awards. Formerly lead guitarist for Arlo Guthrie, Grover has become a multigenerational favorite, appreciated for his storytelling and songwriting abilities, distinctive vocals, and superb guitar work. For over three decades, he has been the headliner at the Great Barrington bandstand every summer. Children adore him. His memorable songs gently teach the important things in life, like family, the environment, and mutual respect. He can be silly or serious, joyful or thought provoking, but he is always heartwarming. More than a legend, he is a Berkshire treasure. Grover is seen here in the late 1980s, on Railroad Street in Great Barrington. (Photograph by Donald Victor.)

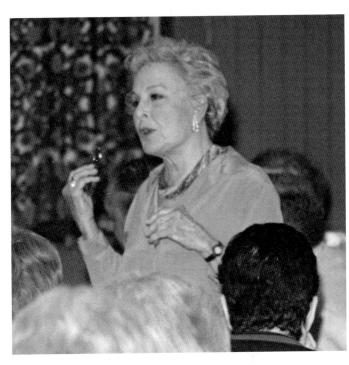

Marge Champion
Marge Champion of Stockbridge is amazing, beautiful, and still dancing at age 94. Born Marjorie Belcher in California, her father was a dance teacher to Hollywood stars. From ages 14 to 16, she was the model/dancer for Snow White in Walt Disney's 1937 animated classic *Snow White and the Seven Dwarfs*. She then modeled for the Blue Fairy in *Pinocchio* and the Dancing Hippo in *Fantasia*. Later, she and her dance partner/husband, Gower Champion, starred in MGM musicals and even had their own television sitcom in the 1950s. She then starred in several Broadway productions (most recently in the 2001 revival of Stephen Sondheim's musical *Follies*) and guest-starred on television programs. Champion choreographed for films like *The Day of the Locusts* and *Queen of the Stardust Ballroom*, for which she won an Emmy. She appeared in an HBO special with Harry Belafonte, and, closer to home, choreographed for the Berkshire Theatre Festival. (Above, photograph by Donald Victor; left, photograph copyright © Disney, courtesy of Marge Champion.)

Olga Dunn

Olga Dunn first set foot in the Berkshires in 1976. She liked the area so much, she developed her own dance school and separate nonprofit organization, the Olga Dunn Dance Company. An amazing 38 years later, both the school and dance company are still thriving. In addition to an annual series of local performances, the dance company has appeared at The Egg in Albany, Jacob's Pillow Dance Festival in Becket, and numerous other venues. (Photograph by Lindy Smith.)

Wray Gunn

Community activist Wray Gunn is a retired chemist/quality control director and past president of the Sheffield Historical Society. As a college student, he was the first African American basketball captain at the University of Massachusetts. He later served as a devoted sports referee for many years. (Photograph by Bernard Drew.)

Elaine Gunn and Michael McCurdy

A community activist for decades, retired schoolteacher Elaine Gunn, seen here in 1994 with Michael McCurdy, remains committed to making the Southern Berkshires a better place to live. She was cochair and coauthor, respectively, of the Upper Housatonic Valley African American Heritage Trail and Guidebook. She was also a key player in establishing the W.E.B. Du Bois Boyhood Homesite National Historic Landmark in Great Barrington.

Michael McCurdy is an award-winning illustrator, author, and publisher who lived with his family near Lake Buel for many years. He has illustrated over 200 books, mostly with his trademark black-and-white wood engravings. His illustrations often have historical or natural themes. McCurdy's Penmaen Press published many high-quality literary works, including first-edition poetry and fiction by leading writers and poets. His superb artwork has also been used in new editions of classics by authors like Louisa May Alcott, L. Frank Baum, and Edgar Rice Burroughs. (Photograph by Donald Victor.)

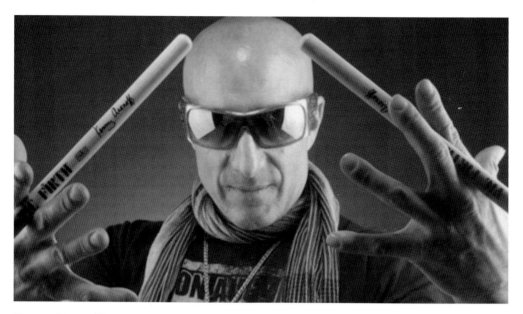

Kenny Aronoff

Kenny Aronoff, of Stockbridge, is one of the world's most influential and in-demand drummers. With a playing style that integrates power with finesse, Aronoff was named the No. 1 Pop/Rock Drummer and the No. 1 Studio Drummer for five consecutive years by the readers of *Modern Drummer* magazine. He has been featured on more than 30 Grammy-nominated recordings and has worked with John Mellencamp, Bob Seger, Belinda Carlisle, Elton John, John Fogerty, Lynyrd Skynyrd, Meat Loaf, Jon Bon Jovi, and many more. He also had a starring role on the Beatles 50th Anniversary Special broadcast on CBS. Also a music educator, Aronoff offers drum clinics, instructional DVDs, and books. (Photograph by Robert Downs.)

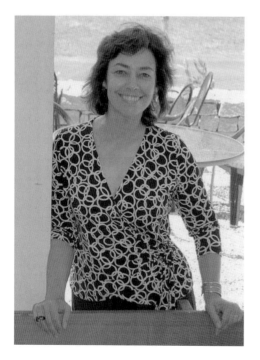

Kate Maguire

Kate Maguire is the artistic director and CEO of Berkshire Theatre Group, which comprises the Berkshire Theatre Festival in Stockbridge and the Colonial Theatre in Pittsfield. Maguire oversees the development, production, and presentation of theater, music, and the performing arts on five stages. Described as "an artistic soul," who is a patient but persistent visionary, McGuire has a wide-ranging skill-set in both management and artistic programming. (Photograph by Larry Murray, Berkshire on Stage.)

Benjamin "Ben" Luxon

Baritone Ben Luxon settled in Sandifield when he married artist Susie Crofut. Already familiar with the Berkshires, he appeared as a regular guest artist at Tanglewood and enjoyed a partnership with folk music legend Bill Crofut. Luxon began as a child prodigy soloist. His professional career was launched in 1963, and he enjoyed a long association with the English National Opera. Luxon's international fame took him from Russia to Japan, Australia to the United States. His unusual musical versatility and interest spans a variety of classical music genres, from Baroque to contemporary, and well as musical theater and folk singing. Active in the community, he is a dedicated volunteer at the Sandisfield Arts Center. (Photograph by Richard Migot.)

Maureen O'Flynn

Singer and actor Maureen O'Flynn grew up in Stockbridge, and she never really left. But her stellar, multi-decade career has taken her to the world's greatest opera houses, including the Metropolitan Opera, La Scala, La Fenice, Vienna Staatsoper, Chicago Lyric Opera, and the Dallas Opera. Although she has graced the stages of the world, her beloved Berkshires have kept her securely tethered to home. Known for her acting as well as her singing, O'Flynn has performed in musical and straight theater, including as Guenevere in *Camelot* and Eliza in *My Fair Lady* with the Berkshire Theatre Festival, and the dual role of Queen/Claudia in Joan Ackermann's *The Taster* with Shakespeare & Company. In 2010, O'Flynn added cabaret singing to her list of diverse talents. Still performing, she also teaches voice at Hartt School of Music and in her private studios in New York City and the Berkshires. (Photograph by Michael Cinquino.)

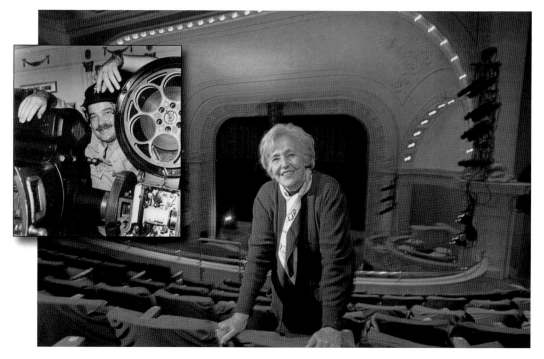

Mr. and Mrs. Mahaiwe

Several gentlemen deserve the esteemed title "Mr. Mahaiwe." The first was Earl Raifstanger (1895–1953), who took over management of the Mahaiwe Theater from his father, Louis. Earl ran the theater from 1925 until his death in 1955. Earl's son John succeeded him as manager, a job he held until 1974, when he resigned to focus on running his popular *Shopper's Guide* publication. Albert "Al" Schwartz (1946–2011), shown in the inset, became the new manager in 1974. He experienced ups and downs as he struggled to keep the theater alive. The title "Mrs. Mahaiwe" goes to Lola Jaffe (above), who has restored the theater and turned it into a successful performing-arts center. (Inset, photograph by Donald Victor; above, photograph by Michael Lavin Flower, courtesy of Mahaiwe Performing Arts Center.)

Mary White Ovington

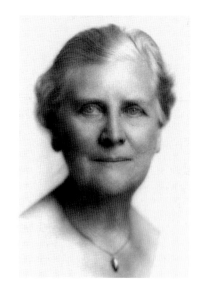

Mary White Ovington (1865–1951) was a founder, director, and treasurer of the National Association for the Advancement of Colored People (NAACP). In 1920, she bought a barn in Alford along Green River and converted it into a summer home that she aptly named Riverbank. Here, she entertained such guests as civil rights pioneer W.E.B. Du Bois and African American author and poet James Weldon Johnson. As a cofounder of the NAACP, she was a member of the "inner circle" that made key decisions and set the tone for the organization. In 1919, Ovington became chairman of the board of the NAACP, working to raise funds and keep the peace among the organization's personalities and egos. (Photograph courtesy of BerkshireArchive.com.)

Violet Heming

In 1940, Mary White Ovington sold her Alford home to retired Hollywood star Violet Heming (1894–1981). The British-born Heming first came to Broadway as a juvenile, playing Wendy in *Peter Pan* and then Rebecca in *Rebecca of Sunnybrook Farm*. She later toured with George Arliss in *Disraeli*. She made a successful transition to silent films, often playing comedic roles, and she remained in demand for decades. Heming also played serious leads, including the allegorical heroine in *Everywoman* (1919). She also had an important role in the 1932 film *The Man Who Played God*. Heming was a founding member, along with Helen Hayes and Mary Pickford, of the Institute of the Women's Theater, a group formed to assist women with stage careers. In 1945, she married US senator Bennett Champ Clark. Pres. Harry Truman was the best man at the wedding. It was Clark who introduced the landmark GI Bill into Congress. (Photograph courtesy of BerkshireArchive.com.)

James "Jim" Bouton

Retired New York Yankees pitcher Jim Bouton has lived in the Southern Berkshires for a number of years. After leaving the Yankees, he played for the Seattle Pilots, Houston Astros, and Atlanta Braves. He went on to become a popular sports anchor for WABC-TV and WCBS-TV in New York City. In 1970, Bouton authored a hugely successful book, *Ball Four*, which offered a controversial, insider's look into the world of professional baseball. After penning several other successful books, he wrote *Foul Ball: My Life and Hard Times Trying to Save an Old Ballpark*, which recounts his efforts to save Wahconah Park in Pittsfield, Massachusetts. (Photograph courtesy of Jim Bouton and Major League Baseball.)

Garrett "George" Troy

George Troy (1884–1944) of West Stockbridge was a legend in his own time. Not because he was a deputy sheriff, garage proprietor, Ford automobile salesman, fire chief, town clerk, and treasurer. And not because his brother Michael was a popular pharmacist, newspaper reporter, postmaster, and Democratic Party activist. George was a local superstar because of his strong interest in promoting semiprofessional baseball. He put his money where his mouth was and built powerful local baseball teams that actually challenged Major League franchises like the Philadelphia Phillies, Cincinnati Reds, and Boston Braves. When famed baseball manager/owner Connie Mack brought the Philadelphia Athletics to town in 1935, more than 3,500 excited fans attended the game at Keresey Field along Route 41. In the above photograph, Troy (right) is seen marching in a 1924 parade. His field of dreams ended in 1941 with the onset of World War II. But the neon Ford sign at Troy's Garage still greets passersby. (Photograph courtesy of West Stockbridge Historical Society.)

Sheffield Stock Car Superstars

Sheffield seems to spawn auto-racing legends. During most of their stellar careers, Richard "Dickie" Larkin (above), Andrew "Andy" Bachetti (right), and Edward "Eddie" Delmolino resided in Sheffield. Delmolino was a star from the 1960s through the 1980s, and Larkin ruled from the 1970s to the 1990s. Both are New York State Stock Car Association Hall of Famers. Present-day fan favorite Andy Bachetti is frequently found in the winner's circle. (Above, Larkin photograph by David Moulthrop; right, Bachetti photograph by Mike Petrucci.)

Russell Willcox
Russell Willcox (1902–1976) was a legendary archer and bow designer from Egremont. It has been said that Willcox did more for the sport of archery design than anyone else in the 20th century. His inventions include the arrow rest, an instrument for measuring arrow velocity, and another for measuring the bend of a bow. Most importantly, he also designed and made the first successful recurve (or duo-flex) bow in 1941. (Photograph courtesy of Egremont Historical Commission.)

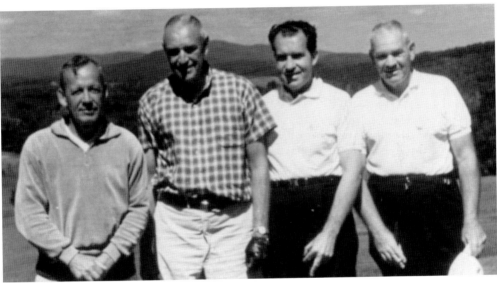

Four in One
These familiar golfers pose for a photograph at Wyantenuck Country Club in the 1960s. At far left is B. Holly Rose of Ashley Falls, who was the brother of Richard Nixon's law partner, Milton Rose of Alford. Also shown here are friendly fuel-oil dealer John B. Hull Jr. (second from left), Nixon (third from left), and golfing great Joseph Morrill. (Photograph courtesy of Wyantenuck.)

Channing Murdock
Ski Butternut has been a mountainside paradise since Channing and Jane Murdock purchased the G-Bar-S Ranch and created Butternut Basin in 1963. In doing so, at the age of 28, they became the youngest proprietors of a ski area in the United States. This photograph was taken in 1989. A few years later, Channing was seriously injured in a bicycling accident. Einar Aas, a champion Norwegian ski racer, joined the team as ski school director in 1964 and served for 43 years until his passing in 2008. Ski Butternut is still owned by the Murdock family. (Photograph by Donald Victor.)

117

Mariano "Mike" Alphonso

Mike Alphonso was one of the most beloved, and most successful, school coaches in Western Massachusetts history. Alphonso (1899–1984) began his career as athletic director at Springfield College. After he came to Great Barrington in 1931, his basketball teams won 21 league championships. His other teams won six baseball league championships, three soccer county titles, one cross-country title, and two Western Massachusetts football titles. He was awarded a life membership in the James Naismith Basketball Hall of Fame and a plaque on the founder's wall. The gymnasium at the former Searles Middle School was named for him in 1986. (Photograph courtesy of Great Barrington Historical Society.)

Anna Kinne Patel

Who was the best all-around, multisport athlete in the Southern Berkshires? When this question is asked, one name consistently rises to the top of the list: Anna Kinne. Granddaughter of legendary coach Mike Alphonso, Great Barrington's Kinne played brilliantly in basketball, soccer, and softball, earning an "All Western Mass" selection in each of the sports. She was voted Best Female Basketball Player in Western Massachusetts two years in a row (1995 and 1996). She was also voted Massachusetts High School Basketball Player of the Year in her senior year. She was inducted into the Berkshire County Soccer Hall of Fame, as well as the Softball and Basketball Hall of Fame. While attending college at Holy Cross, she was named Patriot League Player of the Year and Conference Tournament Player of the Year. She was inducted into the New England Basketball Hall of Fame in 2009 and named one of the Legends of Holy Cross Women's Basketball in 2013. Kinne's coaches described her as a modest athlete who cared more about helping her team and less about individual statistics. Shown here with her daughter Maya, Kinne remains a sports enthusiast and is presently a high school guidance counselor in Connecticut. (Photograph courtesy of Anna Kinne Patel.)

CHAPTER SEVEN

Rebels, Rogues, Rascals, and Eccentrics

He's a rebel and he'll never ever be any good
He's a rebel 'cause he never ever does what he should
But just because he doesn't do what everybody else does
That's no reason why I can't give him all my love
He's always good to me, always treats me tenderly
'Cause he's not a rebel, no no no
He's not a rebel, no no no, to me

—Gene Pitney with Aaron Schroeder,
recorded by Darlene Love with the Crystals

As mentioned in the introduction, nearly 80 percent of this book includes legends and heroes from the past. Over 20 percent of the pages feature those still making a name for themselves. Historian Bernard Drew, however, wisely advised that this unique chapter remain exclusively for those no longer with us. Of course, the temptation to disregard this suggestion was strong, because the Southern Berkshires are home to an entertaining array of present-day eccentrics. Perhaps they will be remembered sometime in the future.

Gil Belcher

Connecticut native Gil Belcher relocated to Great Barrington in 1765. The silversmith moved into a small house on land that included Bung Hill, the rocky outcrop next to the present-day intersection of Routes 7 and 23 East. Belcher discovered a cave on this hill, which he used for nefarious purposes.

Belcher engaged in counterfeiting coins and paper money, probably hiding the dies in the cave. New York currency was still used in the Berkshires at the time, so Great Barrington was a convenient place to create fake "York" money, which was then passed in nearby New York colony. Counterfeiting in Colonial days was common, with some scholars suggesting that fake currency outnumbered the legal variety. In many colonies, including Massachusetts, the crime was not a capital offense. New York, however, was stricter—convicted counterfeiters were hanged—and its currency was more stable. New Yorkers were determined to put a stop to Belcher's activities.

A political firestorm ignited when two sheriffs from Albany crossed into the Berkshires and arrested Belcher and a few cohorts. Although they obtained questionable warrants from Berkshire's sheriff and two justices of the peace, many county leaders were enraged at the actions of the Albany sheriffs. After all, the illegal activity occurred in Massachusetts, not New York. Complaints were sent to Massachusetts governor Thomas Hutchinson and the general assembly. Although the assembly admonished the Berkshire leaders who cooperated with the Albany sheriffs, no action was taken to extradite Belcher. Some suggest that Governor Hutchinson, a Tory, actually favored intercolony feuding because it made cooperation less likely as the storm clouds of independence were gathering.

On April 2, 1773, Gil Belcher was hanged in Albany, leaving a wife and children behind in Great Barrington. His name lives on at the above-mentioned intersection, known as Belcher Square. An old Berkshire Street Railway trolley stand remains on the site of the only park in America named after a counterfeiter. (Photographs courtesy of BerkshireArchive.com.)

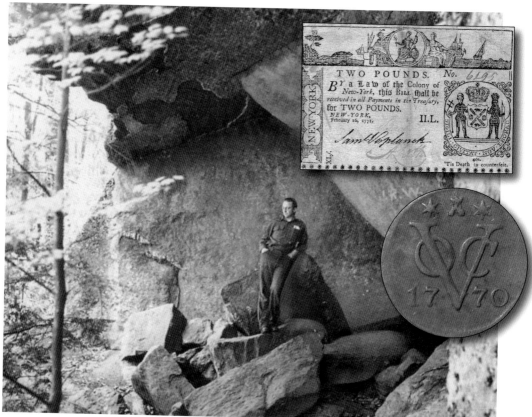

Levi "Beartown" Beebe

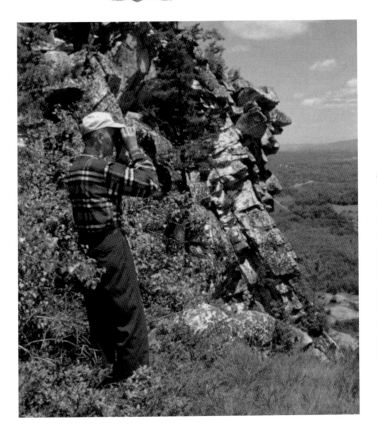

Weather prognosticator Levi Beebe (1817–1900) provided surprisingly accurate forecasts to local newspapers and big-city dailies from his perch atop Beartown Mountain. His fame grew to stratospheric proportions when he predicted the monster blizzard of 1888 months in advance. Beebe was a hardscrabble farmer and logger who owned considerable mountaintop acreage in Great Barrington and South Lee. His complicated and puzzling theories of meteorology were based on everything from air currents to the gait of caterpillars across a leaf. His "scientific" theories were even shared at the Philadelphia Centennial Exhibition in 1876, where he explained, "there is electricity enough in the atmosphere to do the work of the whole world."

According to the *New York Herald*, "Managers of ice companies often inquired of him about the prospects of the ice crop on the Hudson River." But Beebe did not predict his own passing. He died in his sleep in April 1900. It was a cold, windy day. (Photograph courtesy of BerkshireArchive.com.)

Old Man of Monument Mountain

Different faces enjoy the magnificent view atop Monument Mountain, but only one of them is human. The bedrock-born "Old Man of Monument Mountain" has been hanging out here since the last glacier receded, a sturdy survivor who has outlived his fallen brother in New Hampshire. (Photograph courtesy of Great Barrington Historical Society.)

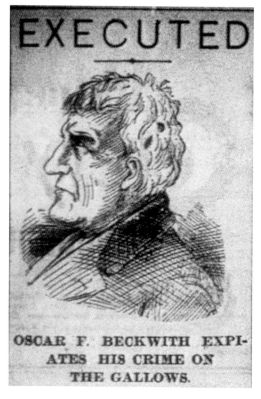

OSCAR F. BECKWITH EXPI-
ATES HIS CRIME ON
THE GALLOWS.

Oscar "Cannibal" Beckwith

A callous culinary crime by Oscar Beckwith (1810–1888) occurred more than a century ago. The strange tale remains food for thought to this day. Although Beckwith's dastardly digestive deed occurred just over the state line in Columbia County, New York, the story remains a gruesome gastronomical legend here in Berkshire.

Beckwith was the overprotective owner of a potential gold mine deep in the woods between Austerlitz, New York, and Alford, Massachusetts. One day in 1885, Beckwith quarreled with Simon Vandercook, his business partner, whom he had grown to distrust. Beckwith murdered Vandercook and chopped up the body inside his dilapidated shanty. He then baked body parts in a wood stove, allegedly dined on them, and salted or pickled other parts for later consumption. In his 70s at the time of the murder, Beckwith was described by authorities as a man "repulsive in appearance" who exhibited "fiendish" behavior. He was finally hanged in Hudson, New York, after several trials, an escape to Canada, and six stays of execution. (Newspaper clipping courtesy of Great Barrington Historical Society.)

The Hermit of Hartsville

In the 1920s, William Warner, also known as the Hermit of Hartsville, claimed that he hadn't slept in 40 years. The Civil War veteran blamed his insomnia on an accident. His claim of continuous consciousness earned him publicity and a meager income from the sale of souvenir postcards. He promoted himself as "Inspirational Bill Warner of New Marlborough, The Scientist of the World." This vague moniker suggests abilities beyond wakefulness. He was also known as "Turnip" Warner because of the sizable crop he raised on his small farmstead. Not surprisingly, turnip greens were used as a remedy for sleeplessness. (Photograph courtesy of BerkshireArchive.com.)

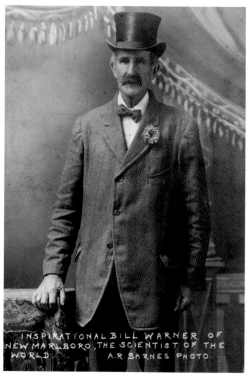

INSPIRATIONAL BILL WARNER OF
NEW MARLBORO THE SCIENTIST OF THE
WORLD. A.R. BARNES PHOTO.

Henry Huntington

Otis and Sandisfield were home to one of the first nudist colonies in the United States. After opening in 1933, the camp was the butt of jokes for many years. Naturist Henry Huntington was a former Presbyterian minister who developed the birthday-suit bastion he named Burgoyne Trail Associates. It was located along North Beech Plain Road, skirting both Otis and Sandisfield. Huntington was the first president of the International Nudist Conference (the National Nudism Organization). In 1933, he became the first editor of the *Nudist* magazine, later called *Sunshine and Health*, the official organ of the American Sunbathing Association. In 1958, he authored a book, *Defense of Nudism*. Huntington's lifestyle apparently served him well—he lived to be 99 years old, passing away in 1981.

Tom Carey

For more than 50 years, Tom Carey picked up mail at the Stockbridge train station and carried it to the post office in his horse and buggy. Tourists were often amazed, and then charmed, by the sight of scruffy Carey in his old hat and long coat. In the hustle and bustle of the 1950s and 1960s, he was a nostalgic reminder of bygone days, interacting with tourists and bringing visitors to their destination. Carey (1881–1967) was honored in a portrait by Norman Rockwell and was featured on this souvenir postcard. (Photograph courtesy of BerkshireArchive.com.)

George "Hermit" Crosby

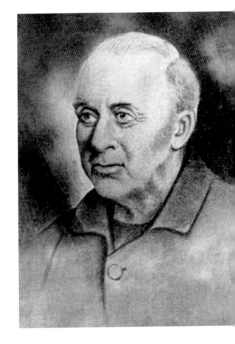

George Crosby of Great Barrington was an odd fellow. As a young man, he fell in love with Alice Skermerhorn, but she apparently jilted him for another man. She then fell ill and died. Heartbroken, Crosby moved to the Brooklyn side of town, east of the Housatonic River near an isolated ravine between Grove and Bentley Streets. Nearby Crosby Street was named after him. The Bridge Street bridge had yet to be built over the river, so here, Crosby operated a small ferryboat he named *Alice*. He was also a talented gunsmith and etched a different name into each of his guns. Their distinctive design makes them highly collectible to those knowledgeable enough to recognize them. When the town voted to build a bridge across the river near his home, Crosby became increasingly agitated and eccentric. Rumors circulated that he roamed the woods, firing off his gun and howling at the moon. One day, he was cornered on Railroad Street, examined by doctors, and sent to an asylum in Northampton, where he died in 1894. His few personal effects were auctioned off. Discovered within an old truck was a faded photograph of his beloved Alice. (Photograph courtesy of BerkshireArchive.com.)

Mary and Edward Searles

It is a challenge to tell the amazing story of Mary Frances Sherwood Hopkins Searles (1818–1891), and her second husband, Edward Searles (1841–1920), in a few paragraphs. Not to mention their legendary Great Barrington castle! Originally called Kellogg Terrace, Searles Castle was built on property once owned by a prominent Tory named David Ingersoll and later by the spinster aunts of Mary Hopkins, who inherited the property. She was the widow of Mark Hopkins, the incredibly wealthy co-owner of the Central Pacific Railroad.

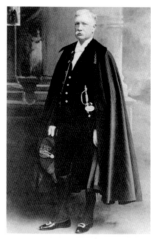

The French Chateau–style mansion was designed by Stanford White, a prominent New York architect. Mary Hopkins hired interior designer Edward Searles to supervise the construction and decoration of the mansion, which was completed in 1888. The widowed Hopkins—who, at age was 68, was more than two decades older than the handsome Searles—fell in love with him. She asked Searles to marry her, and he eventually agreed, shocking 19th-century society. After Mary's death in 1891—just four years after her marriage—Searles inherited her vast fortune and was suspected by some of murdering her. He gradually became disenfranchised with Great Barrington and moved into another of his mansions in Methuen, Massachusetts, where he died in 1920. His fortune was subject to lawsuits by associates and relatives for many years. (Photographs courtesy of Great Barrington Historical Society.)

Zuckerman Zucchini

Zealous Zuckerman Zucchini exists only in the imaginative minds of enthusiastic Zucchini Festival aficionados in West Stockbridge. It is here that the beloved courgette is catapulted, caressed, cooked, and celebrated at a weekend-long summer party. (Composite photograph courtesy of BerkshireArchive.com.)

West Stockbridge Zucchini

INDEX